LOWDHAM, CAYTHORPE & GUNTHORPE

THROUGH TIME

Lowdham Local History Society

AMBERLEY PUBLISHING

Acknowledgements

We would like to thank the many people who made this book possible, including:

Ed Herington – photography
Doug Fletcher, Geoff Firmin, Mabs Thornhill and Gloria Rees
David Ottewell
Anne Sharp and Julie O'Neill – *Not Forgetting Caythorpe*
Tom Shepherd – pilot
All the villagers who provided photographs and information

Lowdham Local History Society

In 1986 a small group of villagers attending an adult education class were encouraged by their tutor to form a local history society. This was duly accomplished and the society went from strength to strength, producing three books and several calendars and Christmas cards. The most recent addition is a compilation of photographs of Lowdham over the years, including some from the two smaller villages in the parish, namely Gunthorpe and Caythorpe.

First published 2012

Amberley Publishing
The Hill, Stroud, Gloucestershire, GL5 4EP
www.amberley-books.com

Copyright © Lowdham Local History Society, 2012

The right of Lowdham Local History Society to be identified as the Author of this work has been asserted in accordance with the Copyrights, Designs and Patents Act 1988.

ISBN 978 1 4456 0836 5 (print)

British Library Cataloguing in Publication Data.
A catalogue record for this book is available from the British Library.

Typesetting by Amberley Publishing.
Printed in Great Britain.

Lowdham

Lowdham, a large, popular, mainly commuter village, is situated 8 miles east of Nottingham. Prior to the arrival of the railway in 1846, it was a thriving centre for framework knitting and fruit growing. There were also three brickyards, many farms and two water mills. The advent of the railway led to a decline in these local industries as people sought better-paid work in the city. The rail company actually provided a special service known locally as the 'rice pudding train', which brought factory workers home from the factories in Nottingham at lunchtime and waited in the sidings until it was time to return for the afternoon shift.

The village is well equipped, with a good primary school, health centre and small library as well as a small number of shops.

Socially, the village is thriving. There are many societies and clubs, public houses and sports facilities. There are three annual horticultural events, a Christmas pantomime and all-year-round live music programmes. Due to an enterprising bookseller, the annual Book Festival has become a nationally recognised event and 'flicks in the sticks' has proved very popular.

On the outskirts of the village is Lowdham Grange. At present it is a Grade B prison. It was built on the site of the first open borstal in the world. In 1930, a group of forty-three young offenders, together with specially selected staff members, marched from a closed borstal in Middlesex to Lowdham and set up camp in tents. They would receive education and develop labouring skills, after which time they would be free to return to society. This was a great success and only came to an end with the advent of the Second World War.

Although situated on the old staging post between Nottingham and Newark, Lowdham does not appear to have been much affected by the Civil War, even though Charles I spent his last night of freedom merely 6 miles away in Southwell. Legend says that a sunken Roman road in Lowdham was named Red Lane due to the blood flowing from a nearby Civil War battle, but it is likely the name derives from its red clay, which is prevalent in the area.

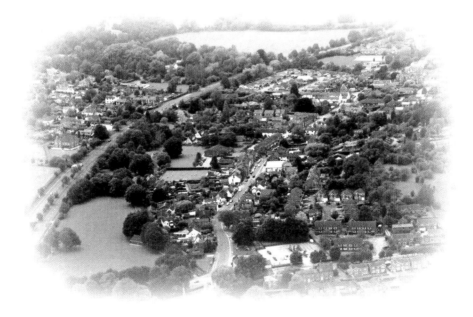

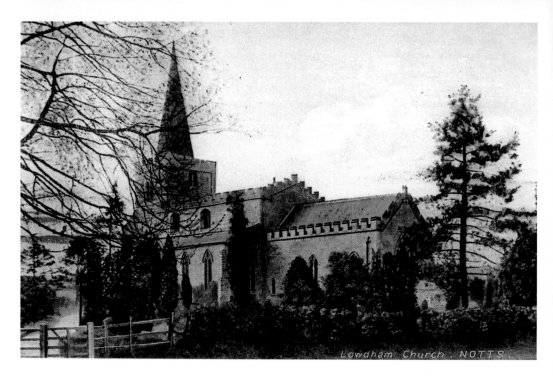

Lowdham Church, NOTTS.

Church and Chapel

The village was founded around the church of St Mary the Virgin, parts of which date from the twelfth century. Over the years it has been extended and remodelled while still serving its purpose. The lower photograph is a much more recent addition to the village. It was built in 1844 by a group of local residents who wished to follow a different form of worship. It still operates as a Primitive Independent Methodist chapel, one of only two still active in the county.

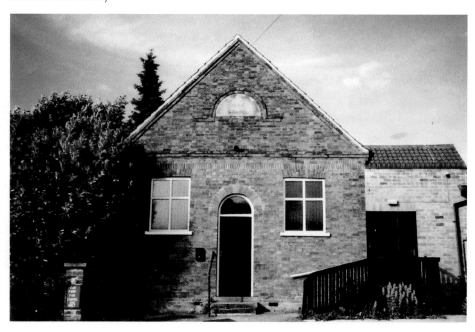

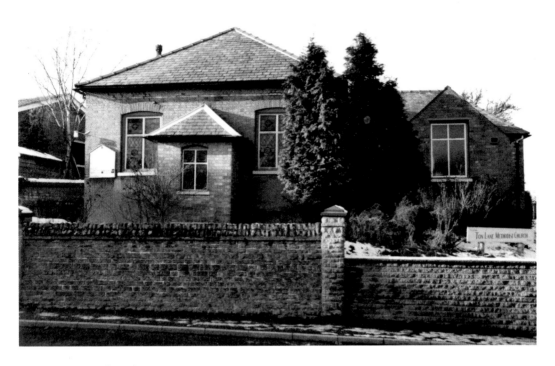

Ton Lane Chapel

Lowdham had another Methodist chapel. It was built in Ton Lane in 1860. Methodism was firmly established in the village by 1831, with a chapel and a Sunday school that operated in a variety of buildings. Falling congregations and other factors resulted in the closure of the building in 1986, which was followed by demolition and the subsequent erection of the house shown here, called Chapel House.

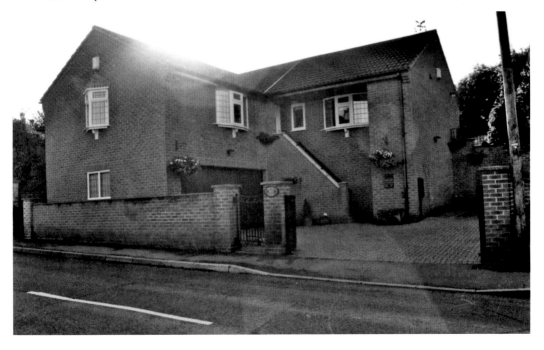

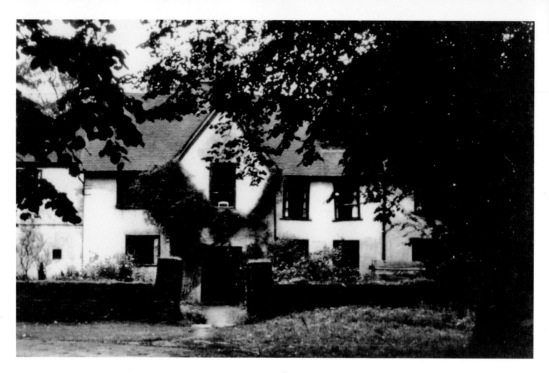

The Old Hall

Originally known as Broughton Hill, this house, dating back to 1620, with its adjacent brick barn from an earlier date, is set within an idyllic site close to the parish church and the Cocker Beck. In the northern part of the garden is the site of a Norman dwelling, which covers the remains of an even earlier occupation – a Roman villa.

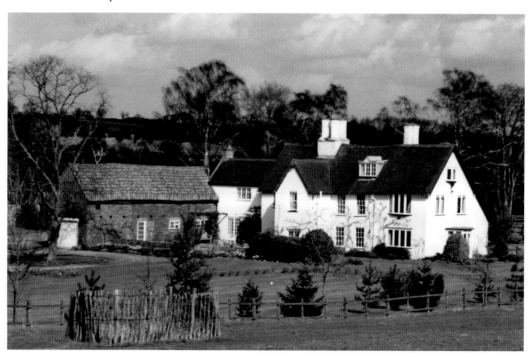

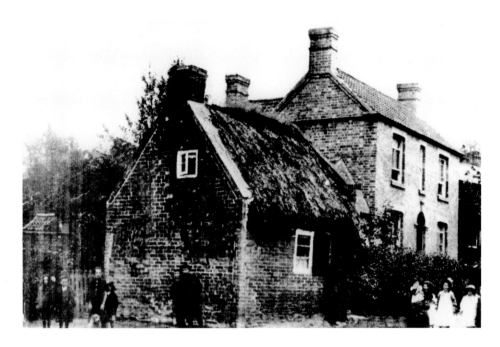

Neighbours Lane

Neighbours Lane is another original byway within Lowdham. It leads from Main Street eastwards over the hill to the village of Gonalston. Part way up this footpath is a 'kissing gate', restricting its use to pedestrians. On the right-hand side of the footpath at the end of the gardens, the bank has been deeply cut away to extract the clay for the bricks that built Lowdham and many other local villages. The tiny, low, thatched cottage and the house in the older photograph have long since gone; the latter was replaced by another house and the cottage by a commercial building, erected in the 1930s for use as a furniture showroom by Shaws, who owned a hardware business on the opposite side of Main Street. The building is now used as a takeaway food outlet.

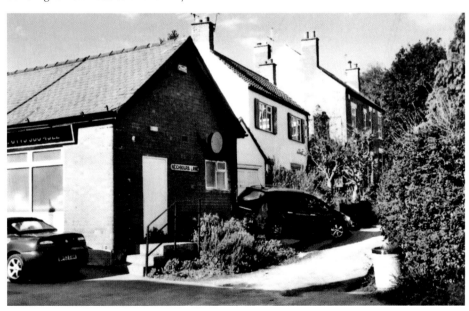

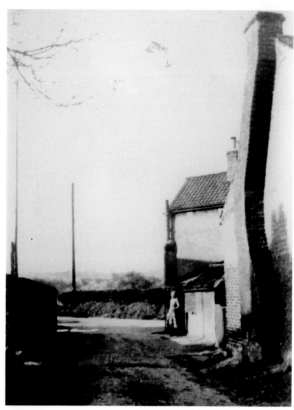

Mount Pleasant
One of the oldest byways in the
village, Mount Pleasant is a short,
picturesque, cottage-lined pathway
leading over the field to the village
of Gonalston. In the older image
there are two cottages on the right;
the lower one remains much the
same, while the other no longer
exists. The scene remains as rural
and pleasant as ever.

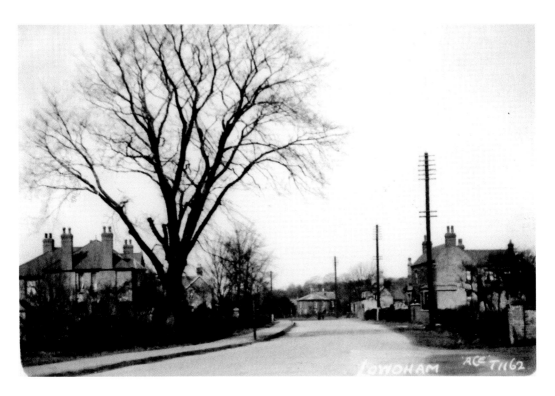

Station Road I

On the right is a double-fronted house now used as a care home. It has a long garden at the side of what was then a family house; the land was probably used to grow vegetables and fruit. Part of the garden is now a new road and a magnificent tree shades the residents' garden. Likewise, the house opposite with the large, leafless tree is now used for building.

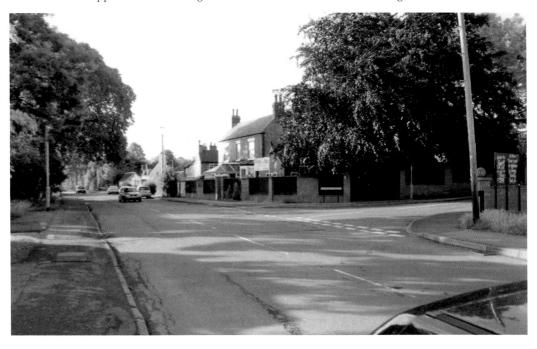

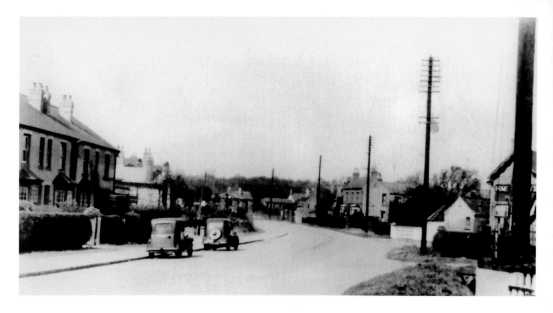

Station Road II

The name of the road is descriptive of its purpose, but it existed long before the railway line cut its curving route, connecting Lowdham with the villages of Caythorpe and Gunthorpe. On the right can be seen the Railway Inn and on the left, bay-fronted villas built in the early twentieth century are visible. The photograph was probably taken from the centre of the level crossing, a position no longer safe. In the modern view, on the right, a new road at the side of the Railway Inn gives access to a housing development, the Sidings, while the houses on the left are now sheltered by mature trees.

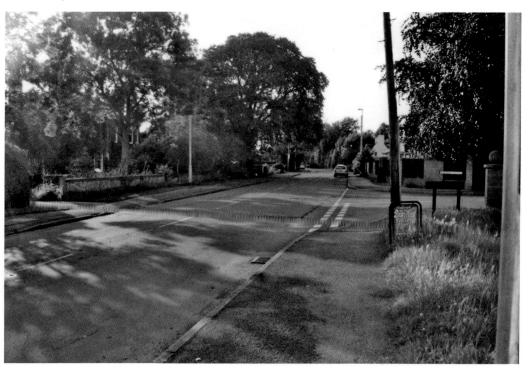

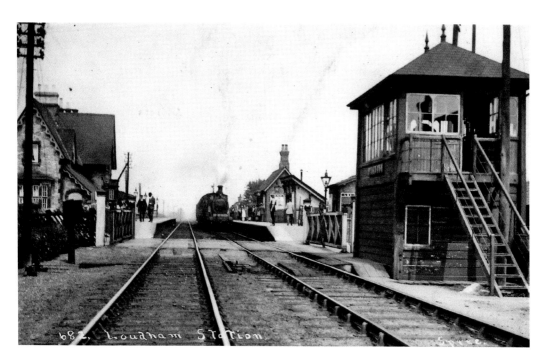

Lowdham Railway Station

The railway came to Lowdham in the 1840s. The twin tracks, on the then southern edge of the village, form part of the route between Nottingham and Lincoln, and the east coast. The postcard view of the station is taken from between tracks, a practice not allowed today. Waiting rooms are visible on both the north and south platforms, along with a gated road crossing, and a host of passengers and staff plus a steam engine. Today, barriers have replaced the gates, small shelters have replaced the waiting rooms with their cosy coal fires, and the trains are pulled by diesel powered locomotives.

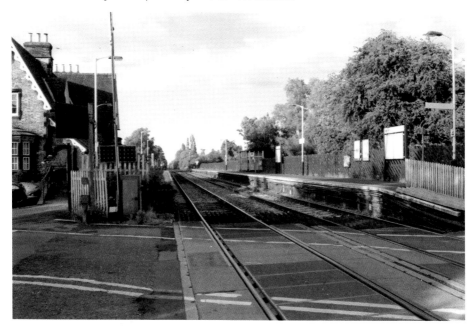

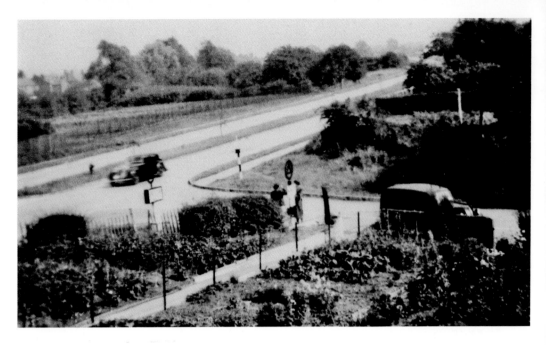

Ton Lane – A6097 Junction

Taken soon after the opening of the road, which divided the village in two, three ladies stop to chat and probably complain about the speed of the vehicle on the bypass at the uncontrolled junction. The lower half of the photograph, which was taken from an upper window of a house on Ton Lane, shows an open garden or allotment. It is no longer possible to take a photograph from the same position. Large trees have filled the open space and a bungalow occupies the corner site. With the increased volume of vehicles, traffic lights are now a necessity for the safe crossing of the road.

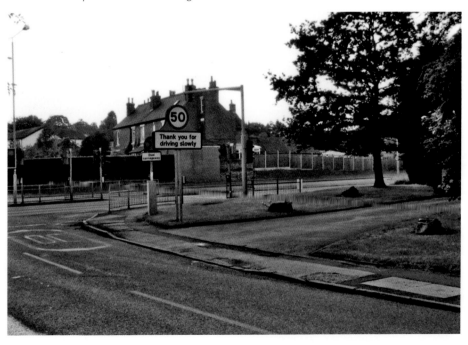

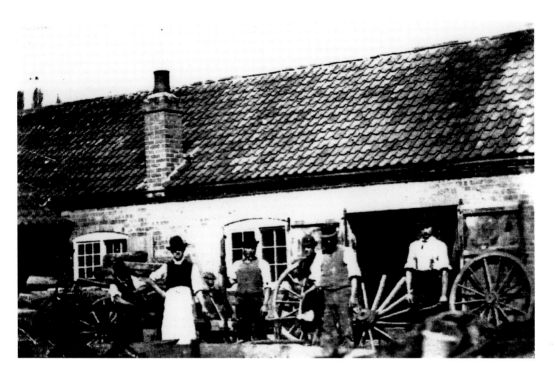

Palings Main Street

These buildings were once cowsheds, later used as a wheelwright's workshop, employing the craftsmen who look bemused as to why anyone would want to take a photograph of their everyday occupation. Opposite the building in view there is a similar row of low brick buildings and the old dairy, now a house, was nearby. The sounds of the saw, the mallet and the men who crafted the wood to make the wheels have long since gone, but the buildings, much altered, remain as workshops occupied by Palings upholsterers.

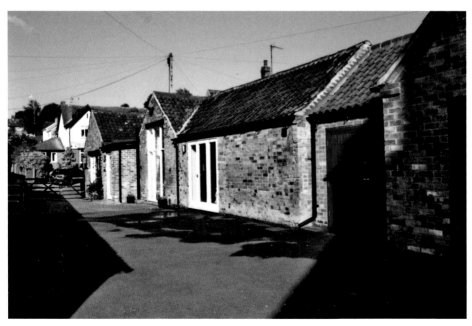

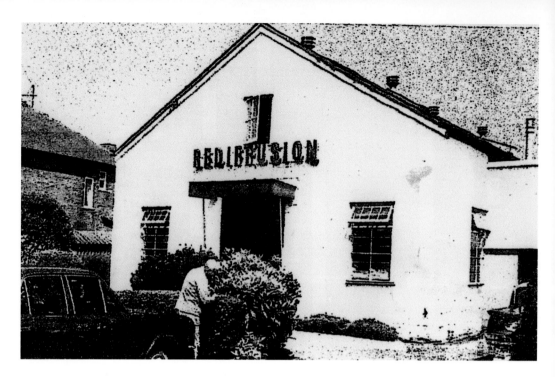

This page and next: **The Pavilion**

Before the provision of the Village Hall, Lowdham had a building that was used solely for entertainment, which was located on Gunthorpe Road. Known as the Pavilion, it was erected in the early part of the twentieth century as a commercial enterprise. It thrived for many years before closure and resale. The new owners were Reffusion, a national wired radio company. Radio cabinets were serviced and manufactured here until its closure in the 1960s. During the Second World War, much of the output was for the armed forces. Following final closure, the building was demolished and the site used for a small housing development called Pavilion Gardens. We are fortunate to be able to include three images depicting the site's history: the exterior, with its trimmed hedge; the ladies working within the house; and the property which now occupies the site.

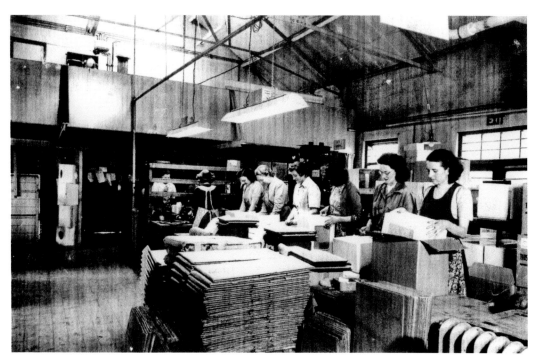

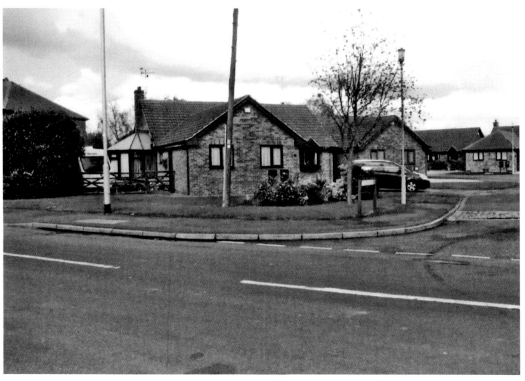

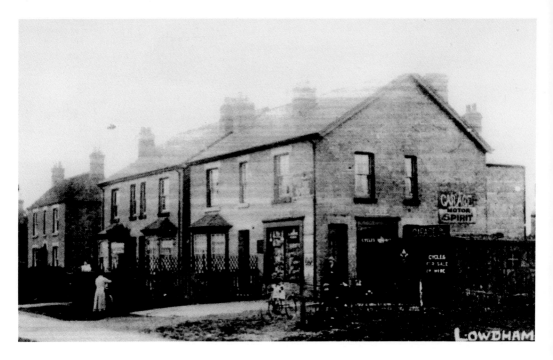

Station Road Shop

Visitors to Lowdham by train could walk a few yards down Station Road and hire a bicycle. Motorists could buy 'motor spirit' for their cars or select goods from the many commodities displayed in the window of this well-stocked shop. The building is still a shop but now advertises its main newsagent business, selling sweets and groceries.

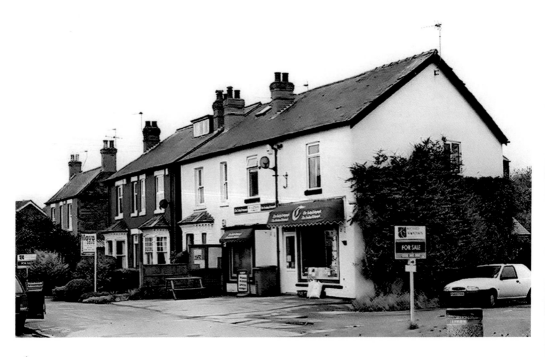

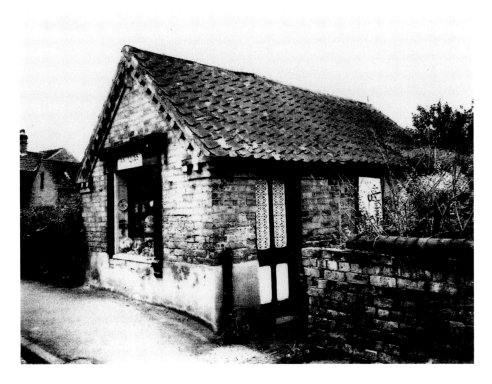

The Butchers

Until recent times, Lowdham had two butcher's shops on the Main Street. The tiny building shown here was owned by the Flinders family for many years. After its life as a butcher's shop it was used by an antique dealer, before it was demolished and a house, 12 Main Street, was erected. Sadly, the last butcher in the village, Carl Salvin, put up his closed sign in 2012. His shop later reopened as an interior design college.

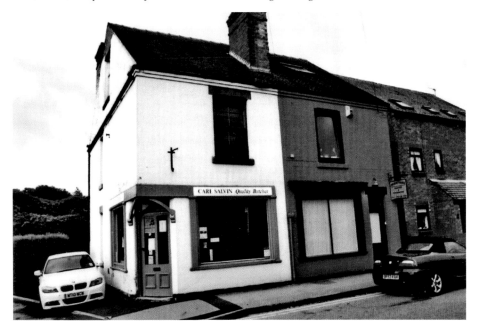

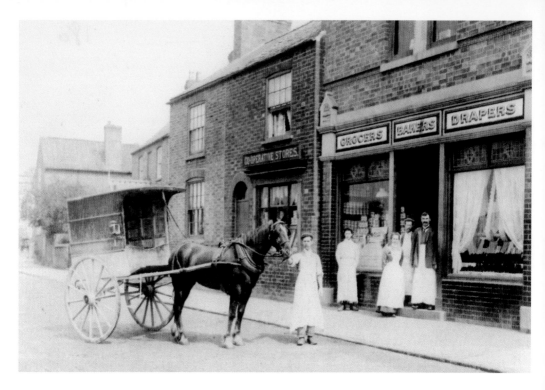

The Co-op

In 1837, a group of Lowdham residents formed a co-operative to provide fair-priced goods for the village and surrounding area. Its title was the Lowdham Industrial & Provident Society Ltd. Over the years, four different buildings have been occupied by the group, all very close to or involving part of the original site. Our images here show the second building in the early years of the twentieth century and the present store, opened in 2005. It is now part of the greater Co-op movement. In the lower left corner, the large, semi-circular, inscribed stone of 1873 can be seen.

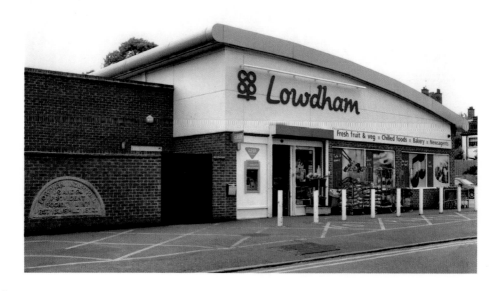

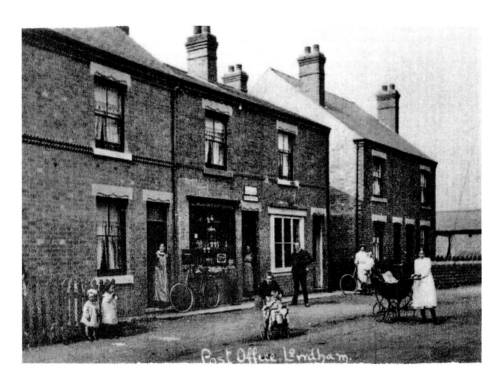

Lowdham Pharmacy

Until the 1970s, Lowdham was well served by local shops and services that collectively supplied nearly everything the residents needed. The village-based midwife brought new residents into the world and a funeral director and monumental mason took care of their departure. Business premises change. In past times the post office occupied this building on Main Street. The frontage has been modernised and it now serves as the Lowdham pharmacy.

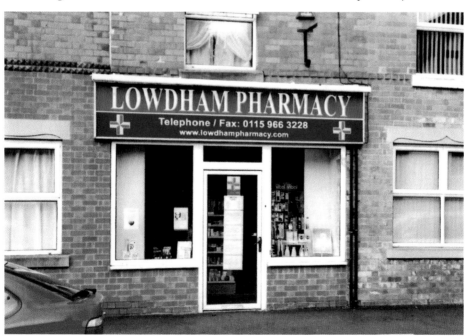

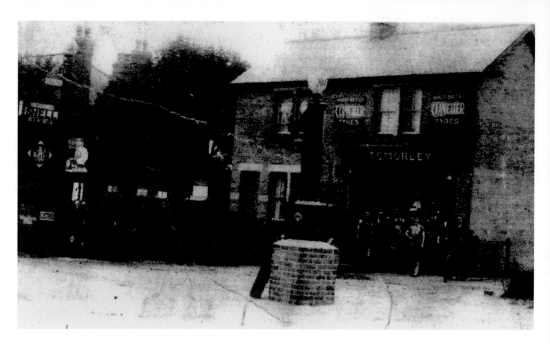

Morleys Garage

Family business continuity is evident in several parts of Lowdham. The Morley family still operate the garage they have owned for several generations. Petrol is still served by an attendant.

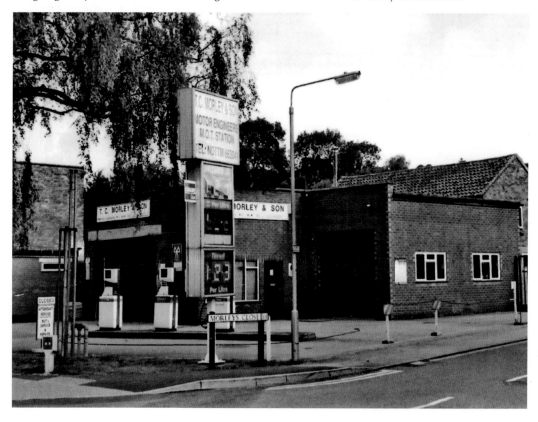

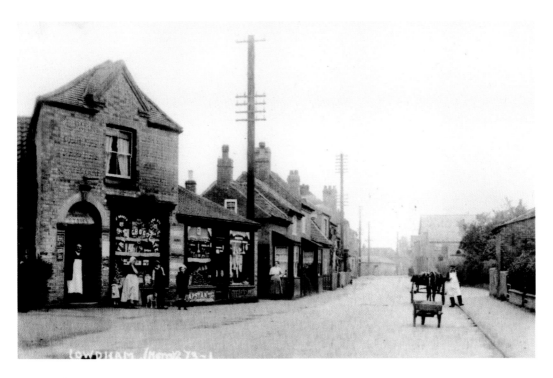

Main Street

In the early nineteenth-century view of the Main Street, the absence of traffic is very evident. The shopkeeper, his customers and passers-by all stop to pose for the photographer; even the driver of the horse-and-cart makes sure that he is recorded for posterity. The horse is not interested. Why was the wheelbarrow casually abandoned in the road? In 2012, the shop is now called Lowdham Stores and there is no curiosity value in somebody taking a photograph. What would the nineteenth-century residents have thought about a shop that displayed a sign advertising a national lottery with possible prizes of millions of pounds?

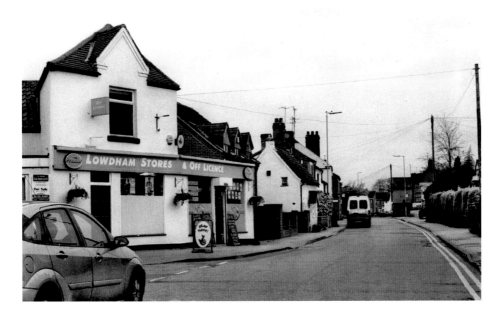

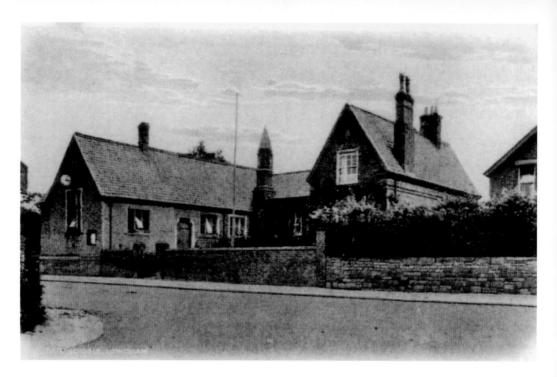

Lowdham School I

Lowdham School opened its doors to the village children in 1843. The L-shaped building and the adjacent schoolmaster's house still stand. The ornate tower has been reduced and it is presently used for domestic dwellings. The modern school opened in 1968 and is a short distance away. It has generous playing fields, surrounded by trees.

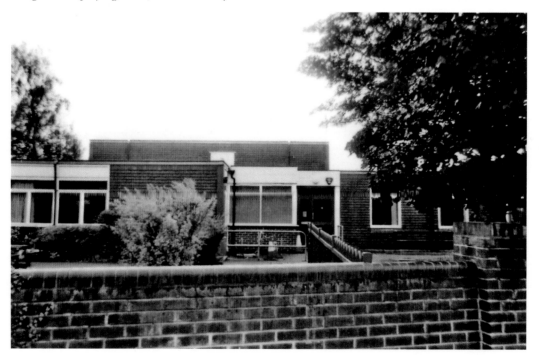

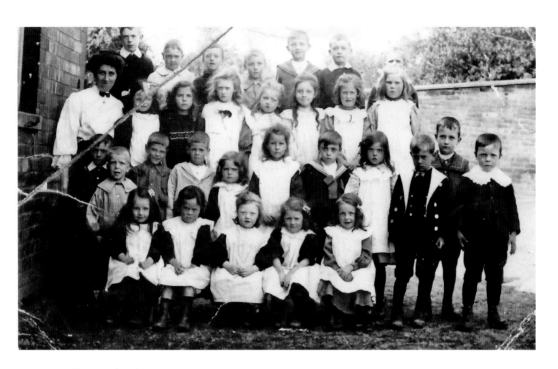

Lowdham School II

Nothing in a school changes as much as the pupils who pass through its doors, sit at its desks and, after a few years, move on. These two photographs, one from 1909 and the other from 1979, are posed in much the same way; the lady teacher is even in the same position, but the pupils of each period were naturally destined to experience very different lives. Which school days were the happiest?

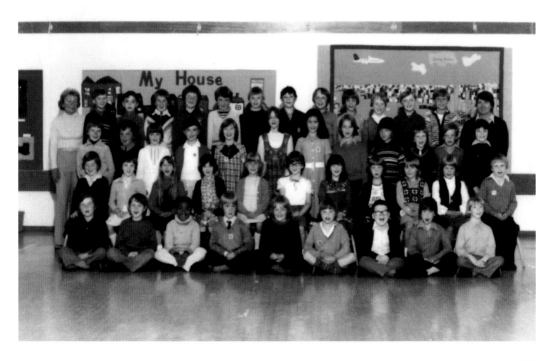

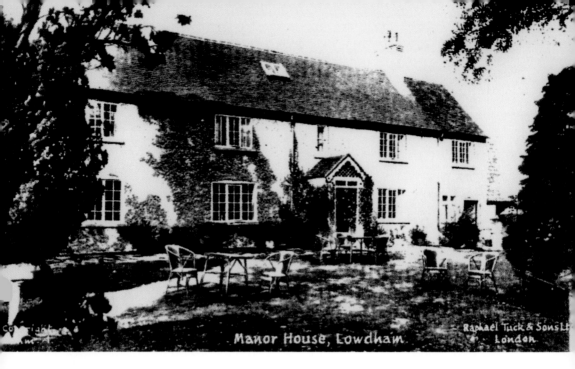

Manor House, Lowdham.

Raphael Tuck & Sons Lt
London

The Manor House, Main Street

This Raphael Tuck postcard depicts the manor house located in the centre of the village. The cane garden furniture, sat within a large, pleasant garden, reflects a period of village life enjoyed by some but different for many others. Later, part of the building on the right of the photograph was used as the village post office, with the postmaster living in part of the house. In recent years, other residences have been erected within the site and the manor house is much altered.

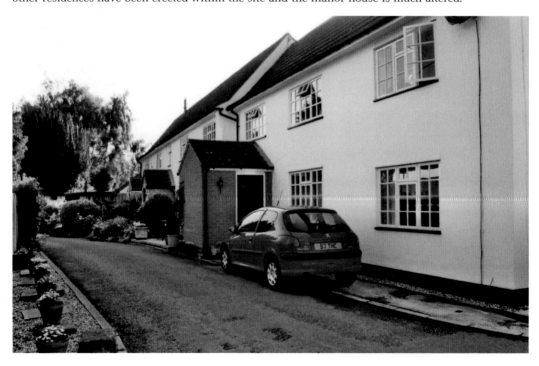

Main Street

Many of the older houses in the village have, over time, been altered to reflect changing styles and the use of gardens and land. 75 Main Street exemplifies many such changes. The house was built in the nineteenth century as a conservative dwelling. Its only decorative features – the brick arches over the windows and the door, the corbelled brickwork below the eaves – all fulfilled structural purposes. A sense of privacy and a demarcation of ownership was provided by the long front garden and the low, iron railing-topped wall. The house today is much changed; the chimneys, no longer needed, have been replaced by a modern, prefabricated flue pipe, the front garden has been reduced in length to provide off-road parking (though a new wall has been built), and the brickwork has been covered with cement rendering. A porch has been added and windows of a different style and shape installed.

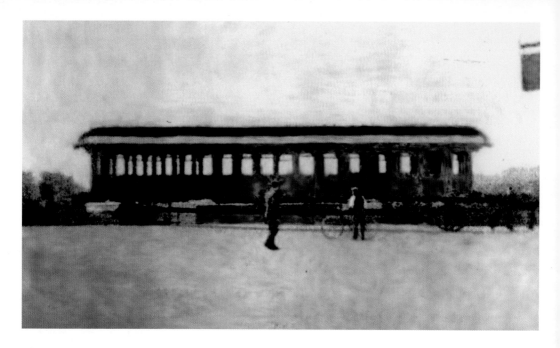

***This page and next*: The Hut**

Perched on top of a hill with views over much of the village, The Hut, as it was originally known, was built in the early 1920s by Mr Alfred Pearson. It was unique in that the upper floor incorporated two American Central Pacific Railway coaches, which Mr Pearson purchased after they had been on display at the Great Exhibition in Paris, 1926. The current house on the site is also unique in its design. A modern country house built of red brick with distinctive decoration, it is an imposing site when approaching the village from the south.

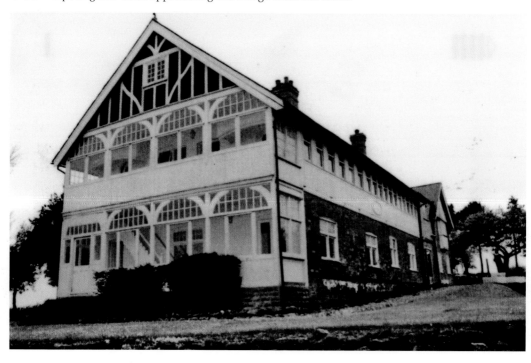

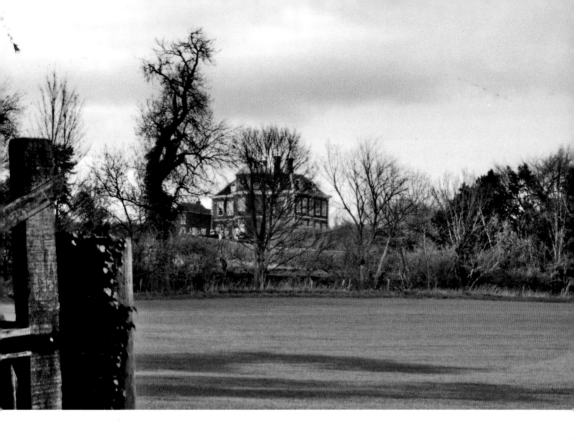

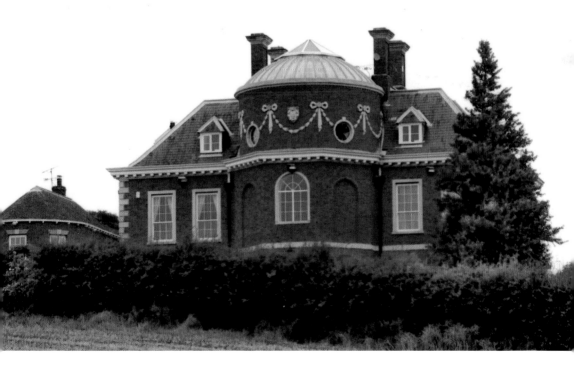

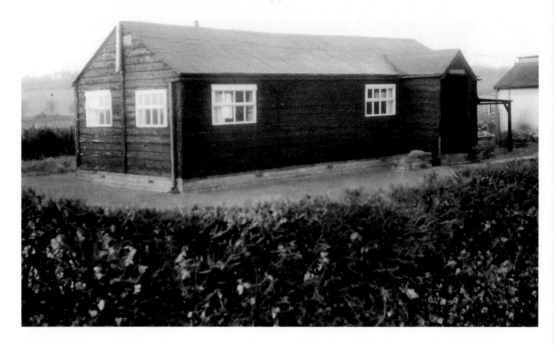

The Women's Institute

Once known as the WI Hut, this wooded building, said to have been acquired from the contractors building the Lowdham bypass (A6097) in the late 1930s, was in use for over fifty years. In 1984, a new brick building was erected and was elevated to the status of the WI Hall. The Lowdham WI was established in 1918 and is one of the oldest in the county.

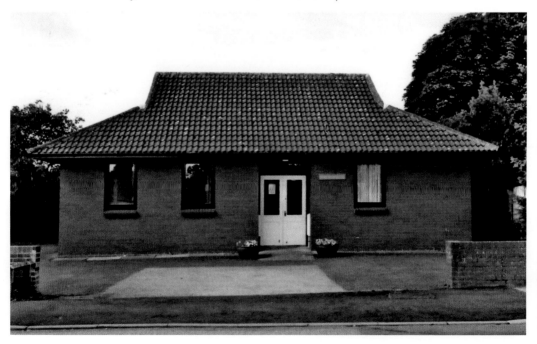

Healthcare

Until the erection of this small, single-storey building, the local doctor treated his patients in a room within his house. The new surgery was built at the side of his residence, probably in the 1930s. For many years, medicines were dispensed by a lady who also held the post of receptionist. On the retirement of the doctor in the 1960s, the house and the adjacent surgery were sold, the latter eventually becoming a residence. The second image (2011) shows the building during a time of extensive renovation. A new building was eventually erected on Barker Hill, the Lowdham Medical Centre.

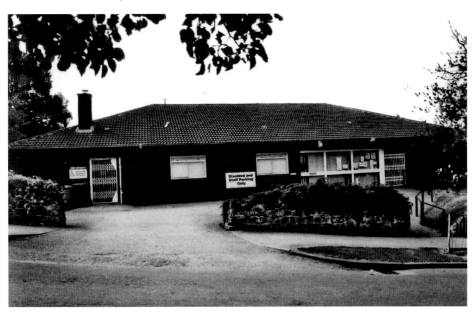

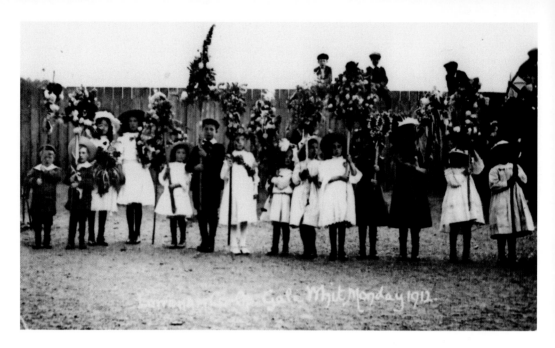

Whitsuntide Celebrations

The Whitsuntide festivities were established as a part of village life for over 100 years. The fancy dress parades were regularly recorded from 1909, when the carriers and farmers allowed their horses and carts to be decked with ribbons and garlanded with flowers to take part in a parade along the Main Street, usually starting at the north end and ending at the Magna Charta Inn. The 1912 photograph shown here captures the children in their Sunday best clothes, with every child wearing a hat or cap. The second image, from 1952, was taken near the Village Hall and shows the fancy dress competitors waiting to be judged.

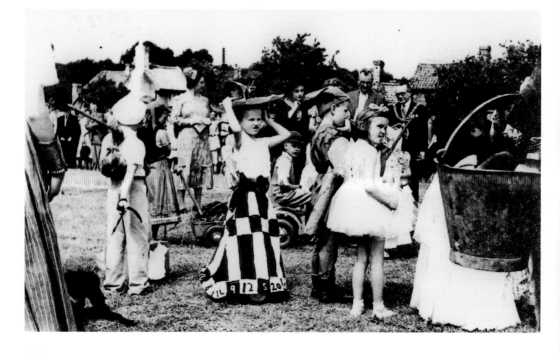

Lowdham War Memorial

Sited on a triangle of land formed by the cutting of a new section of road between the A6097 and the A612, the village war memorial was dedicated in 1921. It bears the names of the sixty-three young men who left the parish to fight for their country in the First World War and did not return. The village population totalled no more than about 1,000, so everyone would have known and mourned the loss of such a number. Fortunately, the casualties during the Second World War were fewer.

In the older picture, the Lowdham Boy Scouts in traditional hats and shorts stand, heads bowed in homage, over the memorial, surrounded by open fields. The more recent image, taken from a different elevation, shows a more mature, well cared-for site. An annual service of remembrance is held here every year.

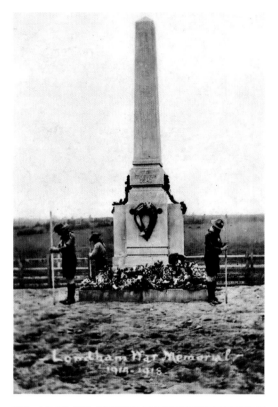

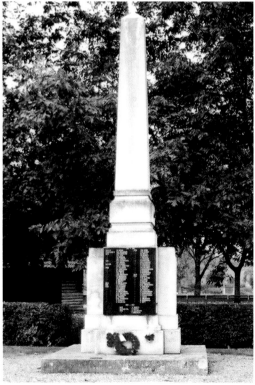

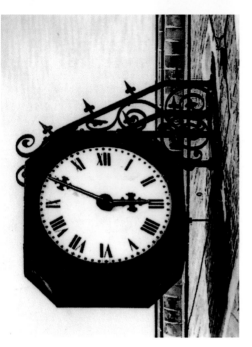
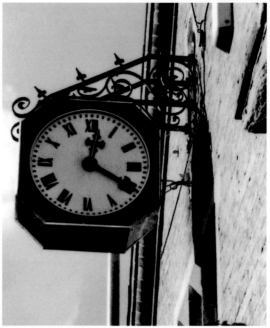

The Village Clock

In 1912, the people of Lowdham celebrated the Coronation of King George V by the purchase by subscription of a public clock. Originally mechanically driven but later converted to electric power, it served the village well for 101 years, but time took its toll and in 2012 a new clock, only slightly different from its predecessor, was installed to celebrate the Jubilee of Queen Elizabeth II. The lower photograph shows the plaques recording the installation of each of the clocks, together with the Clerk of the Parish Council, Lowdham's County Councillor and Mr Julian Banks at the 2012 ceremony.

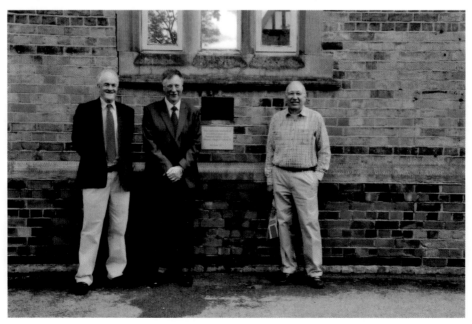

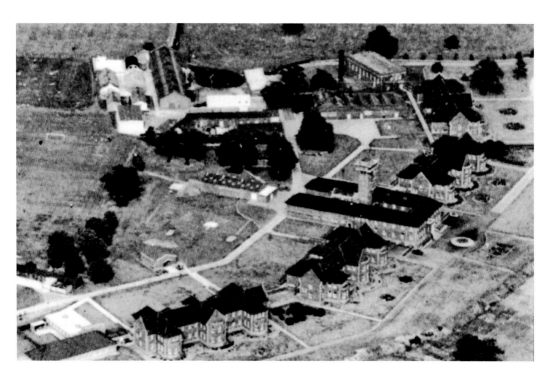

Lowdham Grange Borstal and HM Prison

Lowdham Grange was once one of the larger residences in Lowdham. Located a little outside the village, the house and grounds in 1930 became one of the country's first 'open' borstals, a role it fulfilled until 1981. In this black-and-white image taken in the 1960s, the old grange house can be seen. For several years the site and building remained unused, until in 1997 it was designated HM Prison Lowdham. Subsequently, the older buildings were demolished and the very modern prison buildings that we see in the recent aerial photograph were erected.

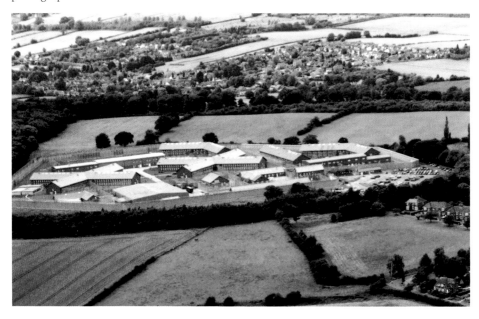

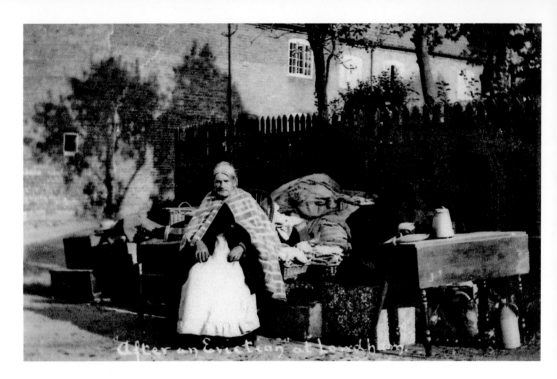

After an Eviction at Lowdham

Old Lowdham

'After an eviction in Lowdham.' A sight we will hopefully never see in Lowdham again. This image of an old lady sitting at the corner of Ton Lane and Plough Lane appears to have been produced as a postcard. Who was she? Why was she evicted and where was her resting place at the end of her traumatic day? We may never know. It is likely that she had lived in one of the small cottages shown on the lower photograph of Plough Lane. They were demolished in the 1960s and the site used for new properties.

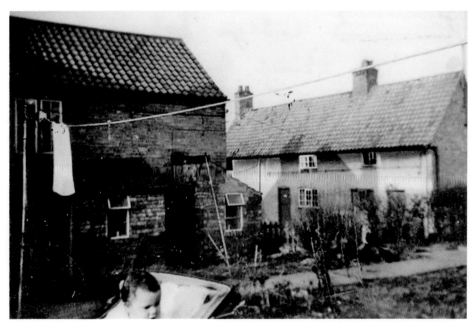

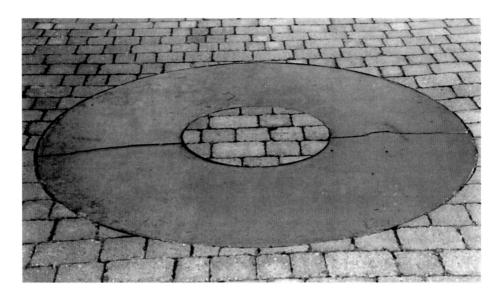

Hidden Gems

These two features have been part of the village longer than any living resident, yet many do not know what purpose they served. The first is a circular iron plate set in the newly cobbled drive of Palings on Main Street. When the premises were used by a wheelwright, a coal or wood fire would be lit on the iron circle and the iron rim heated until it expanded just enough to fit onto the wheel. Once in place the iron was cooled to grip the wood, providing a finished wheel fit for years of service. The plate was recently recovered from another part of the site. Walking along one of Lowdham's footpaths leading from the bypass to St Mary's church, few residents would consider that the grass-covered mound surrounded by water in the garden of the Old Hall is the oldest structure in the village. It is in fact the remains of a motte-and-bailey castle that was once the hub of a Norman enclosure, which probably stretched over the Cocker Beck into the field beyond. The site can claim older provenance; the 1930 archaeological excavation of the mound revealed a Roman floor several feet under the mound. With the Norman church within sight, this must surely be the spot where the village was founded.

The Worlds End (Formerly the Plough Inn)

The name was changed in 1983. On an area of ground known as Worlds End, there was a beerhouse called the Travellers Rest. This fell into disuse when the railway came and a new public house, the Railway, was built near the station. The old beerhouse became a private dwelling. Older residents still refer to the Worlds End as the Plough.

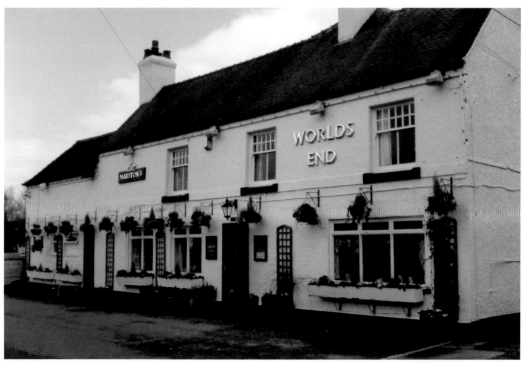

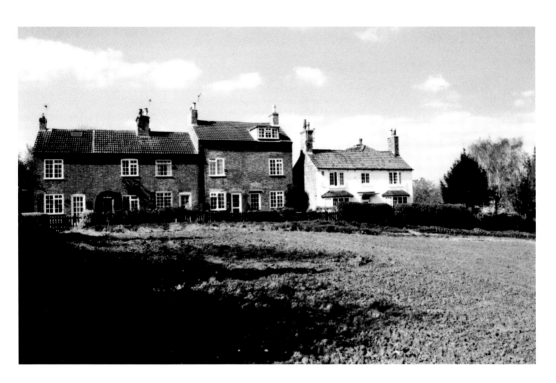

The Travellers Rest

Once a public house alongside the old drovers' road leading from Lowdham to Burton Joyce, this white-painted building now serves as a peaceful dwelling overlooking the Trent Valley and the hills beyond. Its working life came to an end within a few decades of the 1845 opening of the Nottingham–Lincoln railway, with its goods yard at Lowdham station.

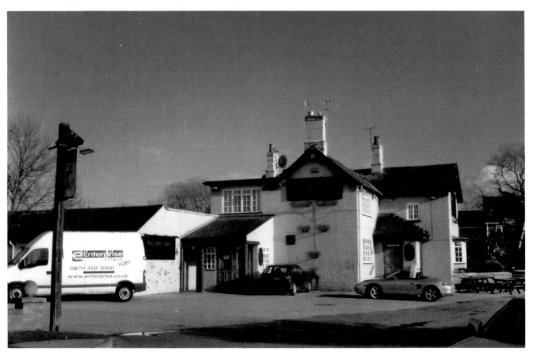

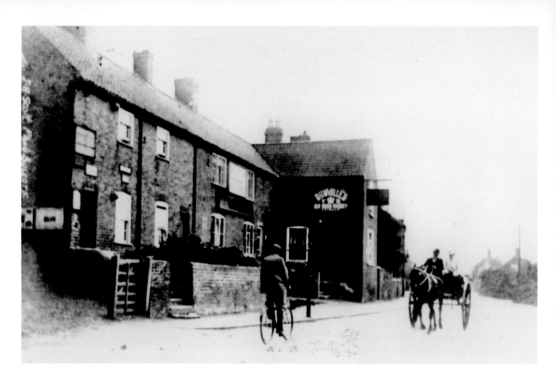

The Ship Inn

The Ship Inn is the most centrally located public house in the village. Now much extended by the incorporation of the adjoining cottages that once housed the village post office, it offers food and entertainment to both locals and visitors.

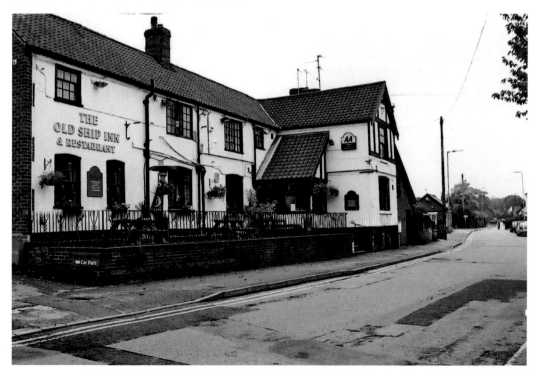

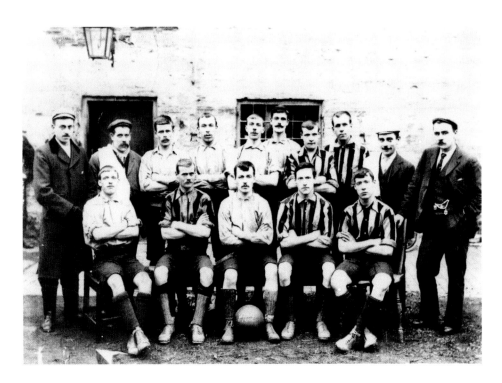

The FA Cup at the Ship

In 1959, when Nottingham Forest won the FA Cup, the then licensees, Jack and Madge Higton, arranged for it to be briefly displayed behind the bar. Alas, Lowdham's 1911 football team never made it to Wembley despite a fine display of moustaches.

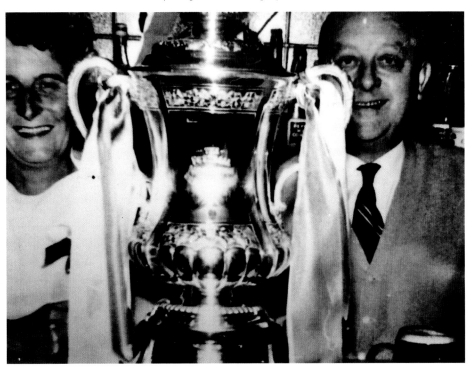

The Old White Lion
References go back to 1834, but in 1925 it was refused a license and reverted to a private dwelling. It still has a plaque on the wall outside.

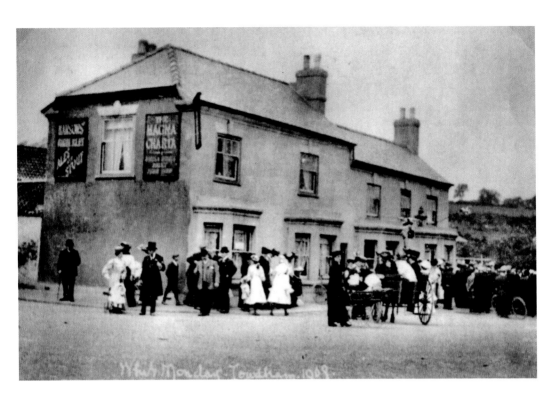

The Magna Charta

This public house probably predated 1824. It is named after a former horse-drawn stagecoach which changed horses here on its journey between Nottingham and Scarborough. One former landlord was Tommy Lawton, the England footballer.

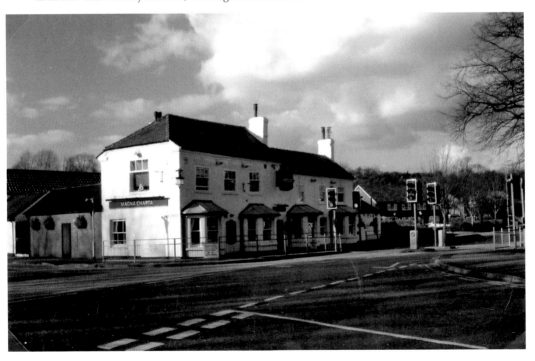

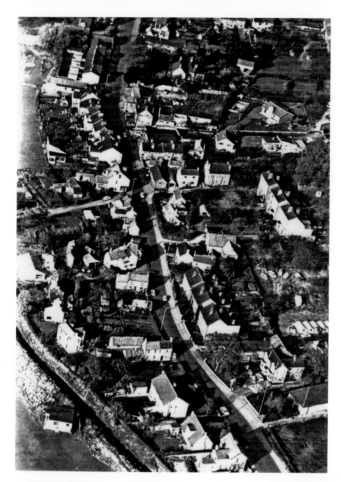

Aerial Photographs

Lowdham, in common with many villages, has changed over the last fifty years. Old buildings once used for work purposes have been demolished and most of the old shops which sustained the community have also gone. Many of the buildings built or adapted to provide working premises for the farmers and tradesmen who both lived and worked along the Main Street have also disappeared. Some remain, adapted to contemporary needs, providing ongoing evidence of continuity and change – hopefully for many more generations.

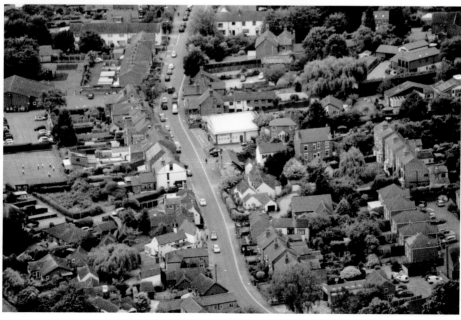

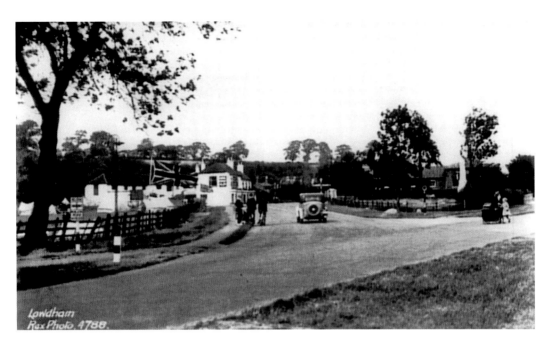

Old Nottingham Road

Perhaps these two photographs of Nottingham Road typify the changes to village life over time. The road of 1927 had no need of road markings and a village mother walks her children along the middle of the carriageway. There are no pavements on the right side of the road. Three cyclists amble along, seemingly unconcerned by the solitary motor car. In 2008, the right-hand road still has wide verges but a pavement further back. Traffic is now controlled and ordered by the use of a pedestrian crossing and traffic lights, and the junction and centre of the road are marked with white lines and an instruction to keep the junction clear. One improvement is the land either side of the road, which now supports a selection of mature trees.

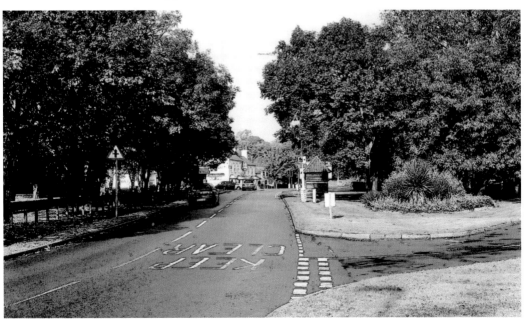

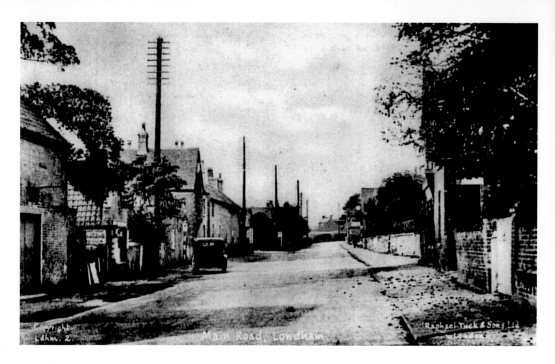

Main Street North

The older of these two views of the Main Street will still be remembered by a few of the residents. Some of the old farm buildings have gone, replaced with new houses; some have been converted to dwellings. The shop on the right, built in the early part of the twentieth century by the Paling family, once housed one of two bakeries in the village. Sadly, only mass-produced bread is now available. It is now a bookshop, the Bookcase. For all the changes, the scene remains rural.

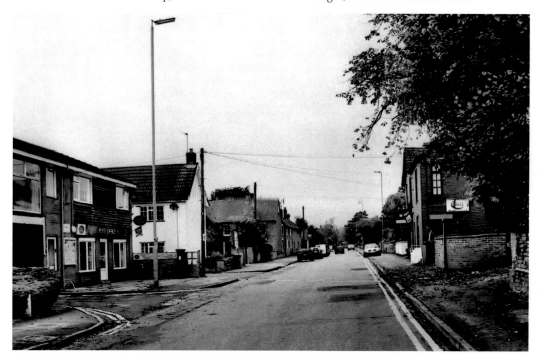

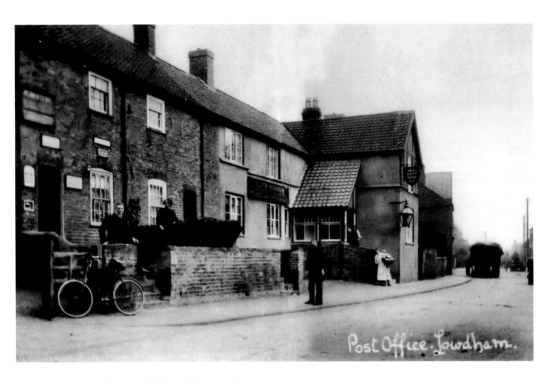

The Post Office and the Golden Postbox

Lowdham post office has occupied a number of sites during its existence. All have been within sight of the current building. Outside each one, the traditional red postbox has stood ever ready to receive the mail. In 2012, that situation was changed when, in honour of our successful local Paralympic gold medallist, Richard Whitehead, the colour was changed to gold.

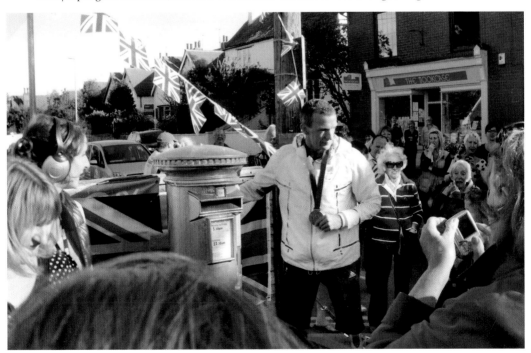

Caythorpe

Caythorpe is the smallest of the three parishes, with a population of around 250. It is a linear village, with no specific centre or green, which stretches for 1½ miles along the road from Lowdham to Hoveringham.

There has been minor habitation here since Saxon times and a watermill since the Middle Ages, when Caythorpe was part of medieval Sherwood Forest. The Dover Beck runs through the village on its way to the River Trent. A small farming community for centuries, the framework knitting boom at the end of the eighteenth century transformed the village. There followed a rapid increase in population to a peak of 315 and the building of many of the red-brick and pantiled cottages typical of Caythorpe today.

The framework knitting boom was over before the end of the nineteenth century, although some production continued into the 1930s. The era was followed by a decline in prosperity and population (now increasing again), together with changing work patterns and demographics.

Most residents now work outside the village, but Caythorpe still retains a strong sense of identity. The following images give an insight into the community, past and present, and the village in which they live. We start on the Caythorpe Road nearest to Lowdham and wend our way through to Brackenhill.

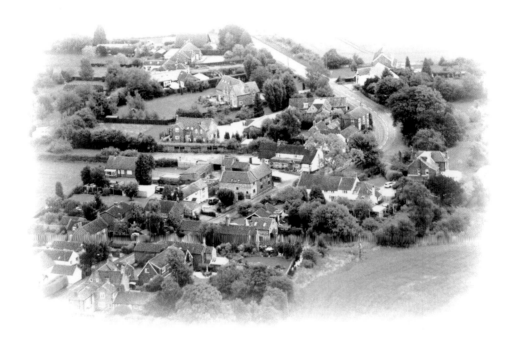

Freiston

Freiston is over 200 years old and lies towards the Lowdham end of Caythorpe. Originally a smallholding, it was firstly called Tamworth Cottage and then Lowdham Farm before adopting the current name around 1960. Subsequently, extensive outbuildings at the rear were converted into a house for family members and modifications were made to the main residence. Note the changed porch and, on the first floor, the old 'Yorkshire slider' windows with leaded diamond pattern.

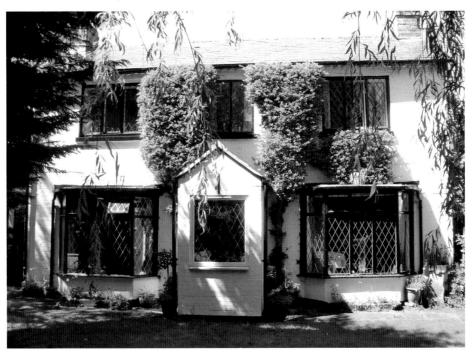

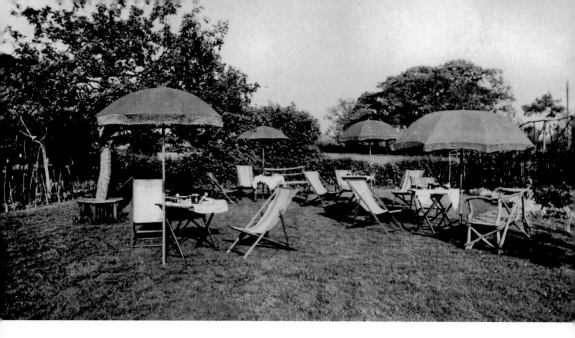

The Old Volunteer

A tea garden may seem an unusual way to illustrate a public house, but this one was very much in vogue with day trippers in the 1930s. That era has now passed and the garden, to the rear, is mostly car park. The 'Old Vol', as it is affectionately called, is a long-established pub and has recently been refurbished. Being located on a fairly sharp bend, the arrival of the pavement opposite has been much appreciated by pedestrians.

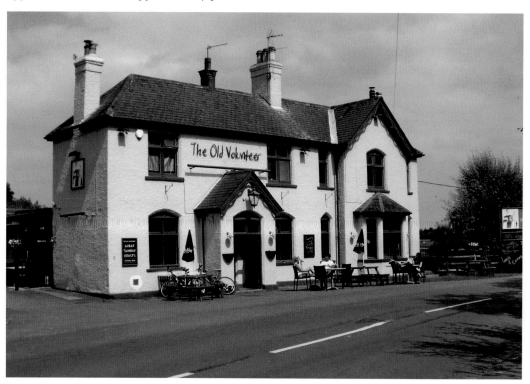

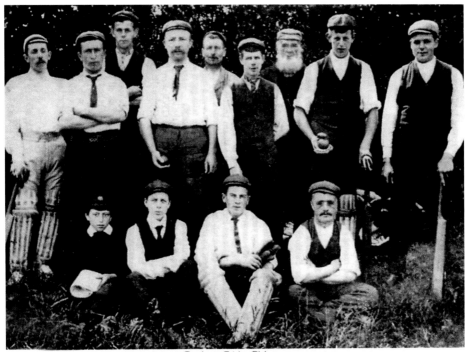

Caythorpe Cricket Club 1904
Back: Sam Bradford, Len Bish, Jack Branston, Charlie Carlisle, Aaron Burton
Sam Foster, George Hancock (umpire), William Branston, Robert W. Branston
Front: Haddon White, William Foster, Harry Linley, Samuel William Foster

Cricket

Caythorpe enjoys its sport and has had a cricket club since the nineteenth century. Originally a village team, it now draws players from a wide area and is one of the leading clubs in the county. From playing in a field opposite Brackenhill, it has relocated to a splendid purpose-built ground on Caythorpe Road. As the images show, there is a strong emphasis on youth, less formality and smarter kit than in 1904!

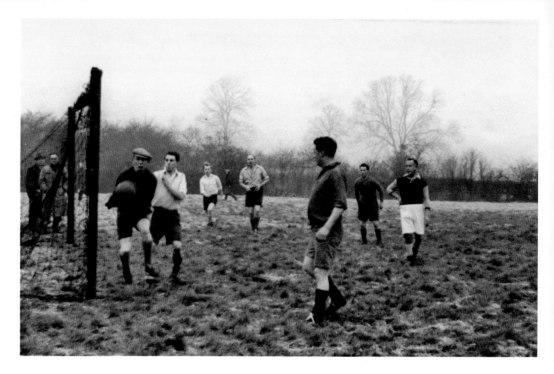

Football

Football has changed! As with cricket, it was played for many years on a rough old pitch opposite Brackenhill. Today it is played on the manicured grounds of Caythorpe Cricket Club. Equipment and strip are somewhat more sophisticated than shown in the 1950s, but no doubt the enthusiasm is still the same. The team featured is Lowdham Colts, a highly successful local youth football club.

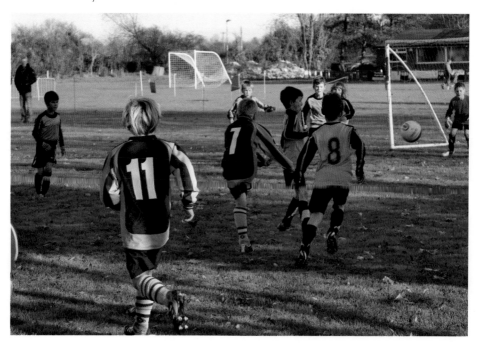

Prebends Croft

The original cottage is Grade II listed, with parts being timber-framed and recorded as seventeenth century. Later, 'The Croft' became part of the framework knitting industry. At one time it was occupied by Clara, daughter of Thomas Foster (see Bridge Cottage) and her husband Samuel Foster. Clara worked for her father as a hosiery seamer in a small workshop at the rear. The property has had several owners since and was extended in the late twentieth century.

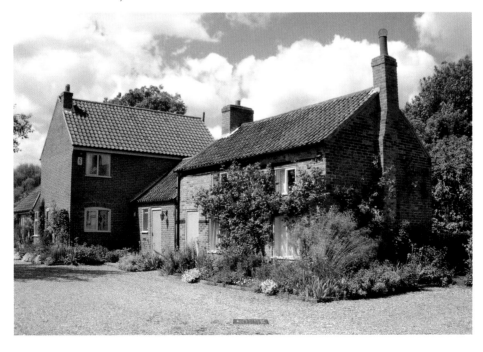

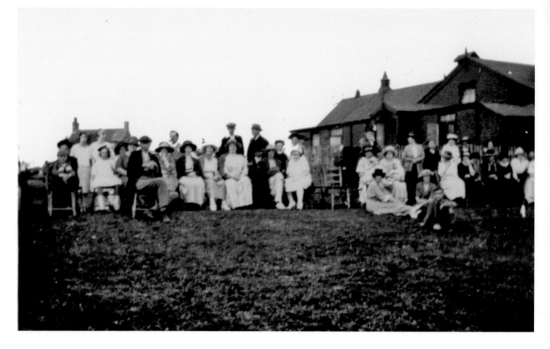

Village Hall

Caythorpe War Memorial Hall, to give the full title, was built after the First World War to provide both a memorial and a permanent village amenity. It has achieved this magnificently, being the setting for a host of social activities and the annual village show. Since the opening, seen in 1923, the front has changed but the main hall behind is little altered. Note St Aidan's quaint bell-tower peeping above the roof in both images and, in the background, Manor Cottage, which has been extended.

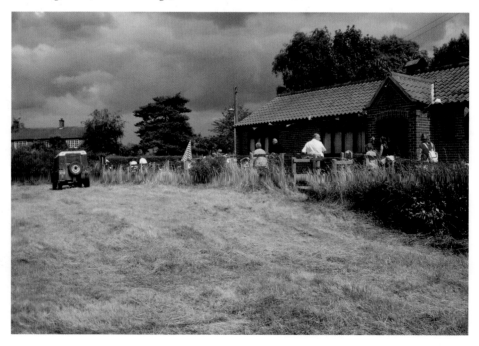

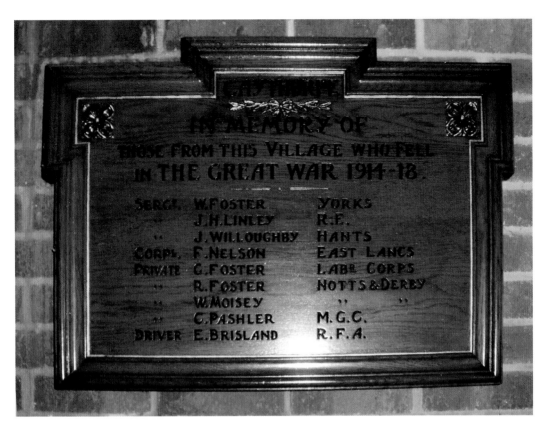

IN MEMORY OF
THOSE FROM THIS VILLAGE WHO FELL
IN THE GREAT WAR 1914-18.

SERGT.	W. FOSTER	YORKS
"	J.H. LINLEY	R.E.
"	J. WILLOUGHBY	HANTS
CORPL.	F. NELSON	EAST LANCS
PRIVATE	G. FOSTER	LAB. CORPS
"	R. FOSTER	NOTTS & DERBY
"	W. MOISEY	" "
"	C. PASHLER	M.G.C.
DRIVER	E. BRISLAND	R.F.A.

Inside the Village Hall

The reminder of why the Hall was built is to be found inside and shows the names of nine villagers. Relatives of some of these still live in the surrounding area. Also illustrated is an example of the village enjoying making use of the Hall on one of its popular quiz nights, complete with fish-and-chip supper and ample libation, courtesy of BYO.

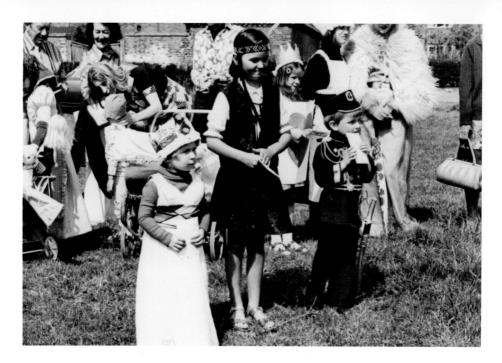

The Village Show

The show has taken place on the first Saturday in August for as long as anyone can remember. There is the traditional 'Vegetables, Flowers, Cakes' component, with prizes for the best, then cream teas, an art exhibition and a variety of sideshows and competitions. Among the most popular is the children's fancy dress, the themes of which may change over the decades but not the enthusiasm and sometimes trepidation of children and parents alike.

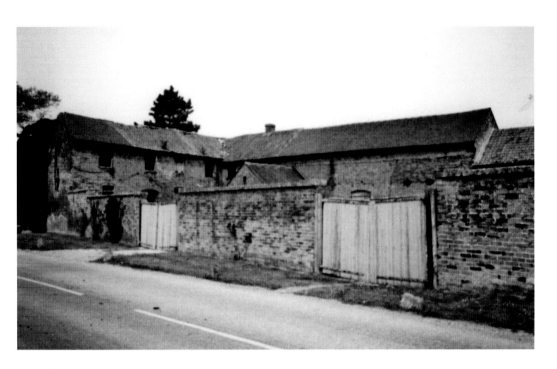

The Byars

Opposite the Village Hall, these eighteenth-century barns formed part of Manor Farm. They gradually fell into disuse and were converted into a nursing home, opening in 1993. The conversion and subsequent extensions sympathetically retain the character of the old buildings and The Byars has become a much respected and valued amenity for the local community and county.

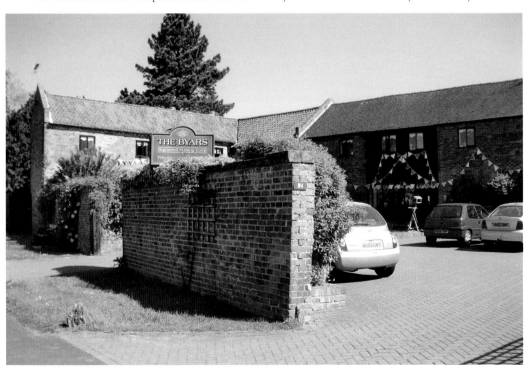

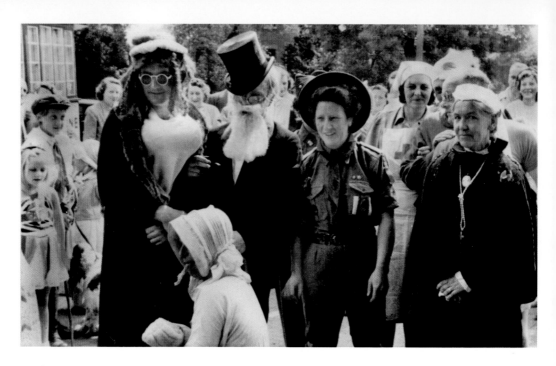

Having Fun

Caythorpe residents enjoy having fun and celebrating big occasions. The adult fancy dress took place during the Festival of Britain in 1951, when young and old alike paraded from the Black Horse to the Village Hall; the adult egg-and-spoon race, along with many other silly games, followed a magnificent hog roast in celebration of the millennium. St Aidan's church is seen behind.

Taking Tea

The Village Hall features again in this pair of images. The tea for the old folks of the village depicts a more formal era and was taken in 1948, before the Hall was altered. The second shows an altogether more casual approach in both dress and style. Tea is still available but there is plenty of other liquid refreshment on view. The marquee is on the field alongside the Hall, where show events are held.

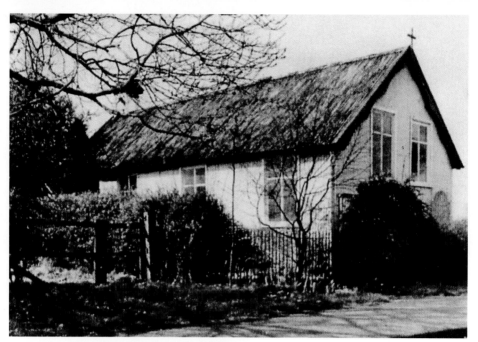

St Aidan's Church
This small chapel of ease was built in 1900 to provide a local place of worship for Caythorpe's Anglican community, who had previously travelled to Lowdham. Known as a 'tin tabernacle' because of its corrugated-iron and timber-frame construction, St Aidan's has been a working church for over a century but had never been licensed for marriage until a request was made in 2008. There have been several weddings since.

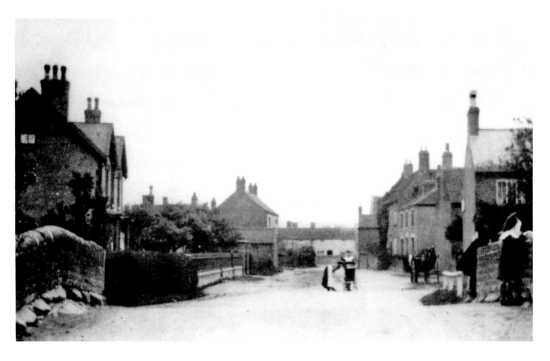

Main Street from Dover Beck Bridge

A familiar sight, looking east from the Dover Beck bridge. The trees have grown since the 1900s but this charming street of mainly red-brick cottages and pantiled roofs is little changed. Noticeable differences include a reshaped bridge and the introduction of pavements and road markings, not to mention more contemporary forms of dress and transport! Note also the traditional red phone box, now owned by the village and used as a book exchange.

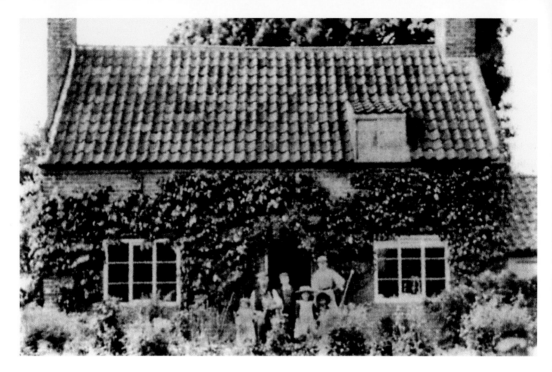

Bridge Cottage

Alongside the Dover Beck, Bridge Cottage was home to generations of Thomas Foster's family, well known in the framework knitting industry. Their workshop was next door. The workshop and Bridge Cottage are now tastefully incorporated in a much larger property that has retained the character of the original buildings.

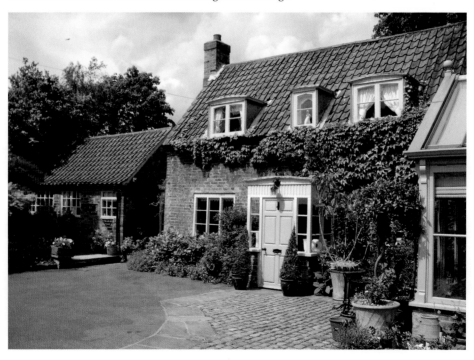

Warehouse Yard

A grim-looking Main Street around 1950. On the left are the dilapidated frame shops of the once-thriving 'Warehouse Yard'. They were subsequently demolished and the terraced cottages behind converted into one residence, The Croy. Note the bus timetable on the end workshop (none run these days). There is now a small bungalow behind the wall. Opposite, two new properties replace the row of cottages, whose gable end can be seen. On the immediate right, the entrance to Marton Cottage remains.

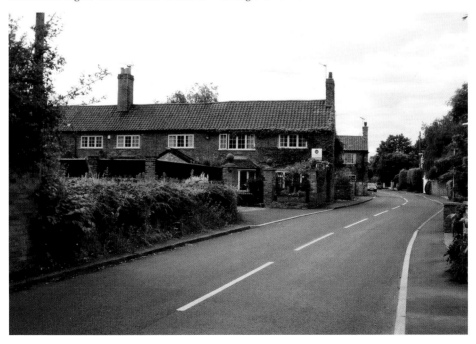

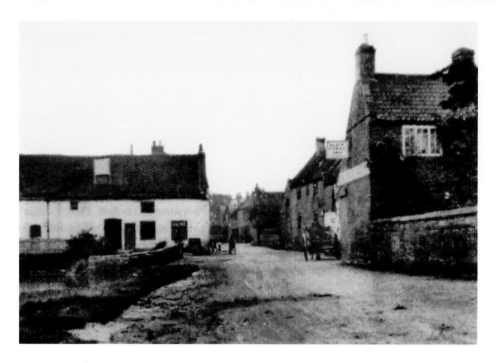

Main Street from the Black Horse

Several changes are evident since the 1920 photograph. The wall alongside the Black Horse has been lowered and conceals a car park. Solar panels can just be seen. Branston Cottage on the right has extended. The Mill opposite has been shortened, revealing the pantiled roof of The Croy. Note the daffodils: planted throughout the village to celebrate the millennium, they create a delightful picture in the spring.

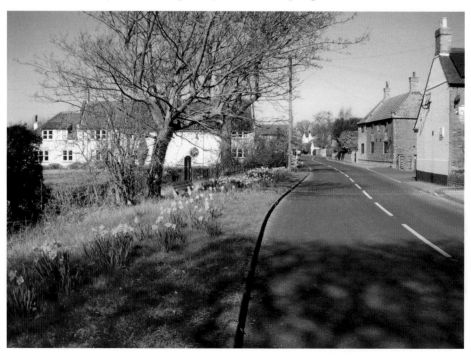

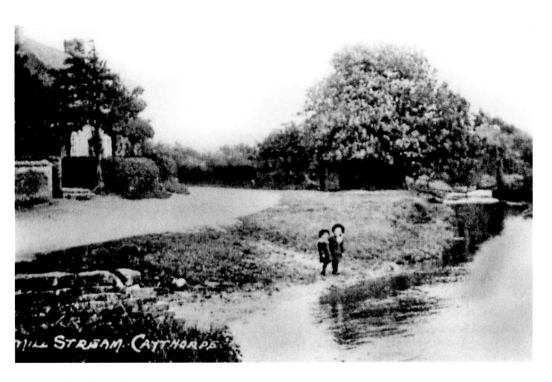

MILL STREAM · CAYTHORPE

Beside the Beck

The children, photographed in the 1900s, are standing beside the Dover Beck at the lower end of Main Street before the road turns towards Hoveringham. There was a ford at this point but, unused for many years, trees and vegetation have grown unimpeded and the bank has gradually heightened. Red Tag and Holly Cottages are still visible before the bend.

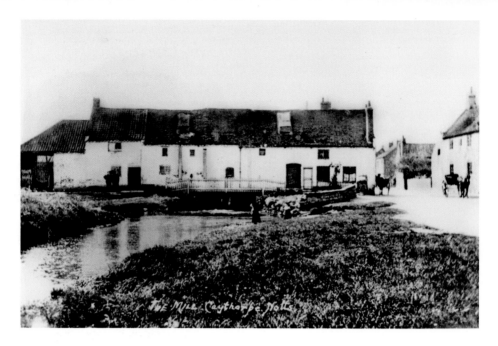

Olde Mill

The present mill dates from 1745, although there have been water mills here since the Middle Ages. Originally one of thirteen on the Dover Beck, this is the last before the Beck joins the River Trent. The mill ceased grinding corn in the early 1950s. Soon after, the miller's cottage at the front was demolished and the remaining buildings were converted into a private residence. Currently, this also houses a studio pottery.

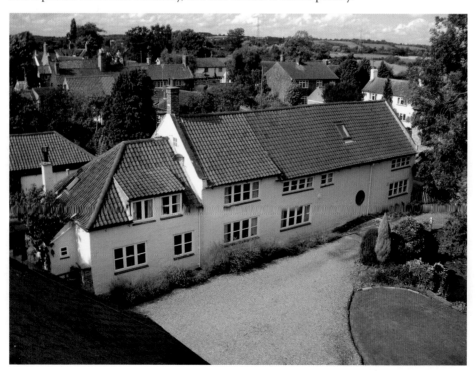

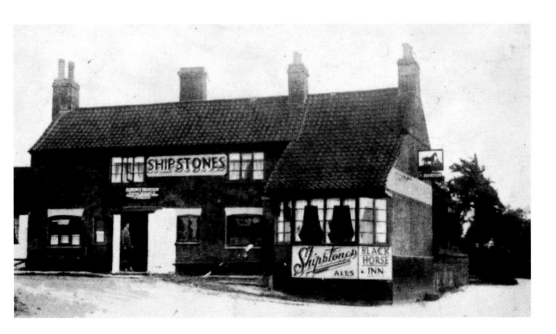

The Black Horse

Over 300 years old, the Black Horse is one of the oldest buildings in Caythorpe. Dick Turpin, the highwayman, reputedly took refuge here and the name is said to derive from his famous horse, Black Bess. Owned from 1880 by Shipstones, a local brewery, the pub became a free house in 1995. Since then many internal and external improvements have been made. Note the enhanced exterior and attractive new entrance. There is also a microbrewery on site.

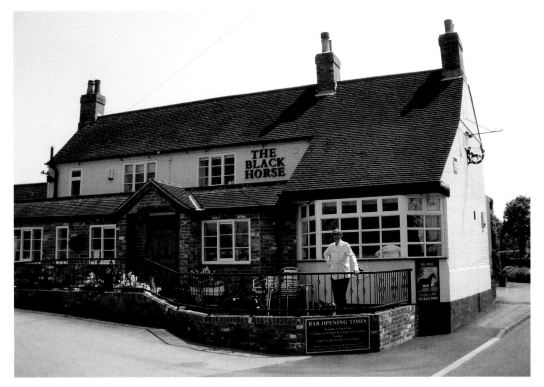

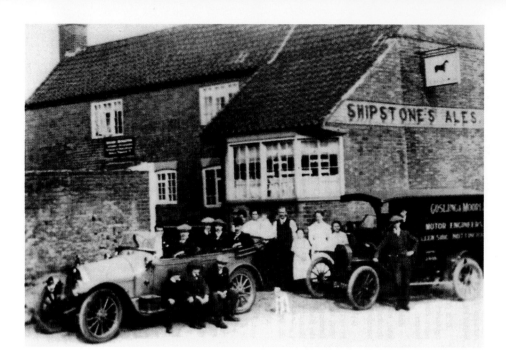

Outside the Black Horse

The Black Horse is a 'people' pub, renowned throughout the county but also very much at the heart of its own community in Caythorpe. Villagers have gathered here for all sorts of occasions down the years so there was no more fitting place to see in the new millennium. The top image shows a get-together in the 1920s of the well-known Branston family, members of whom were tenants of the pub into the 1950s.

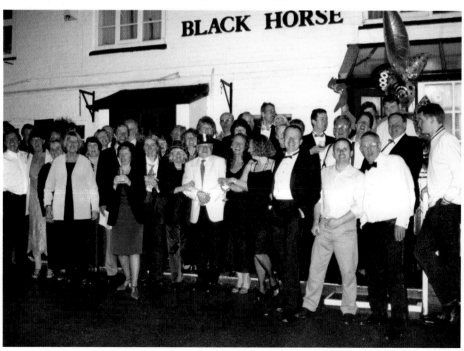

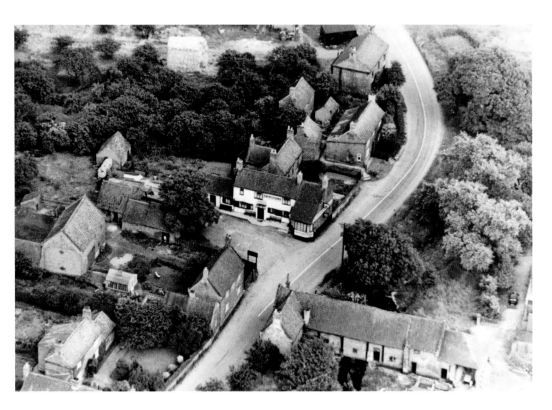

Aerial View, Main Street

A good example of how the east end of Main Street has changed from the more rural character captured around 1950. Note fewer trees and less turf, new properties and extensions, the conversion of the mill, including the removal of the miller's cottage at the front, changes to the Black Horse frontage and the disappearance of the cottage immediately behind.

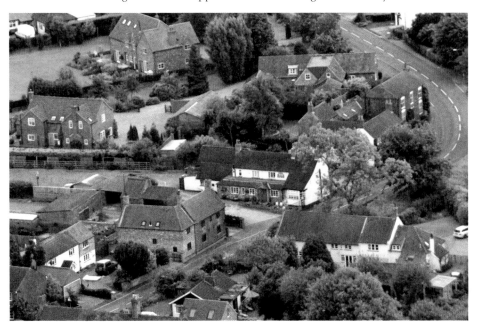

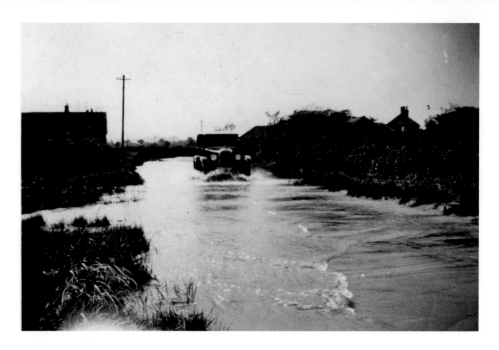

Floods

Lying on the flood plain of the River Trent, Caythorpe has been vulnerable to flooding for centuries. Currently floods happen about every twenty years. They cause severe disruption for a few days then things settle down, except for the mopping up! Here we see a magnificent old classic car powering through the 1934 floods on Caythorpe Road; then, further along the road in 2000, a Range Rover apparently pursuing a more appropriate mode of transport!

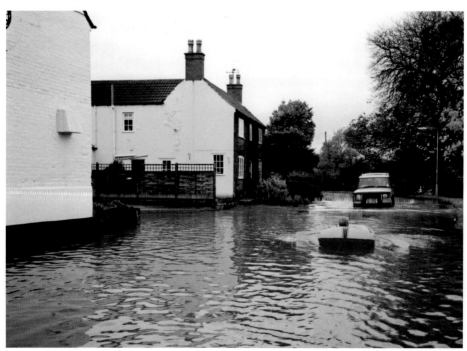

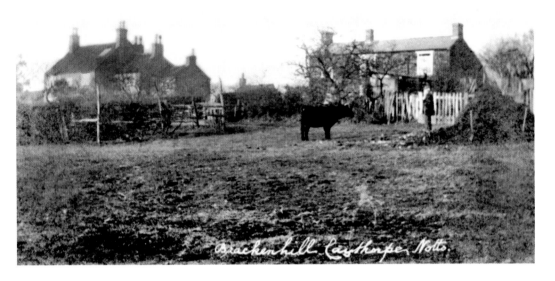

Brackenhill

The rural nature of Brackenhill in the early 1900s is evident. Corner Cottage, on the left, was previously part of the framework knitting industry. Note the attached buildings, now separately owned and modified. Today the rural character is maintained although the cottages are less visible due to a new hedge and trees. Immediately below the hedge is a delightful footpath going across the fields to Hoveringham.

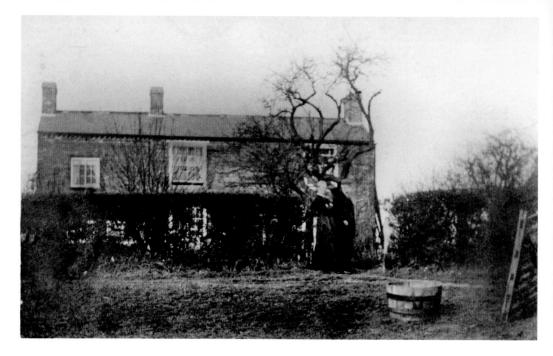

Jessamine Cottage

Like Corner Cottage, at over 200 years old this was one of the earliest buildings on Brackenhill. It was perhaps a bakery at one time, certainly a smallholding. A typical rural cottage when photographed in 1908, Jessamine today still retains its traditional character but has been transformed into a comfortable and charming modern property with a beautiful garden.

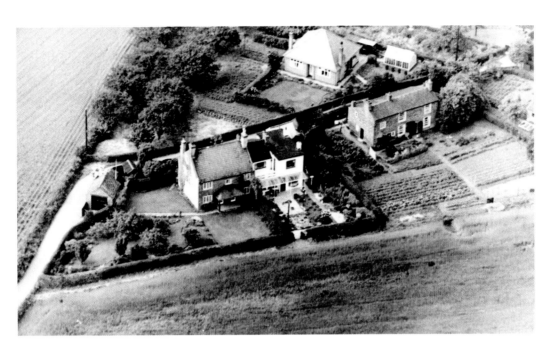

Aerial View, Brackenhill

Taken from a slightly different angle, the modern photograph is more comprehensive than the first, taken about 1955. Two new properties and some modifications can be seen but in essence Brackenhill remains a small and distinctive enclave, still surrounded by open countryside. Note the extension of the hedge across Jessamine's boundary, indicating the end of smallholder activity and providing continuous separation of field and houses.

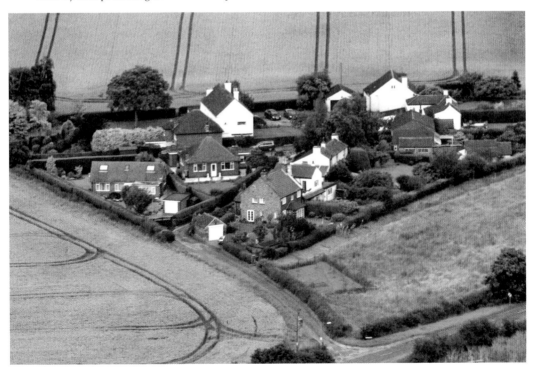

Gunthorpe

Gunthorpe lies close to the River Trent in Nottinghamshire. It has been a settlement near to a ford across the river since Roman times and some authorities believe there was a Roman bridge across the river leading from Margidunum on the Fosse. It is rumoured that Boudicca defeated the IX or X Legion near here.

During the nineteenth century the village, which had been mainly agricultural, adopted the trade of framework knitting, which continued producing underwear until the First World War. A few machines were still in operation in 1930. The advent of the railway through Lowdham in the 1840s provided access for the villagers to travel to work in the factories that were springing up in Nottingham.

The toll-bridge, built by Gunthorpe Bridge Co. in 1927, created a more reliable way to the south than either the ferry or the ford that had operated previously. In 1927, when the lock was built following the dredging of the river, the Council purchased the toll-bridge, demolished it, and opened the much larger free bridge so that motorised transport had access to the south and the Fosse Way. This bridge, the only crossing between Nottingham and Newark, now carries considerable traffic along the A6097, which bypasses the main village. Gunthorpe, as a result, has become mostly a residential village, although there are several restaurants near to the river that are regularly patronised by visitors.

Although only a small village, the population of Gunthorpe increases in the summer months, when tourists visit this attractive stretch of the River Trent, especially fishermen, ramblers and water-skiers.

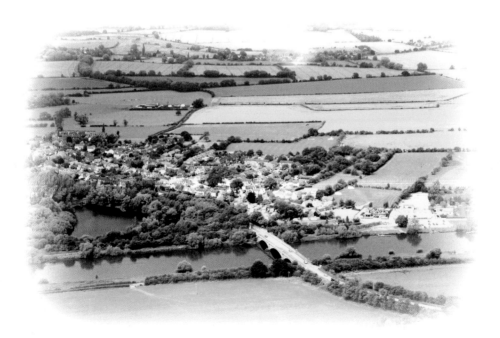

Witsend Cottage
At the back of the Witsend Cottage was a stockinger's shop, which was reached by steps up to the entrance.

Askew Cottage

Askew Cottage, now a much-altered single cottage, was once three cottages, with one very small cottage in the centre and two large ones either side. One of these larger ones was, at one time, inhabited by the village dressmaker. This was most likely a converted framework knitter's cottage as the windows were originally of the long-paned style to let in more light.

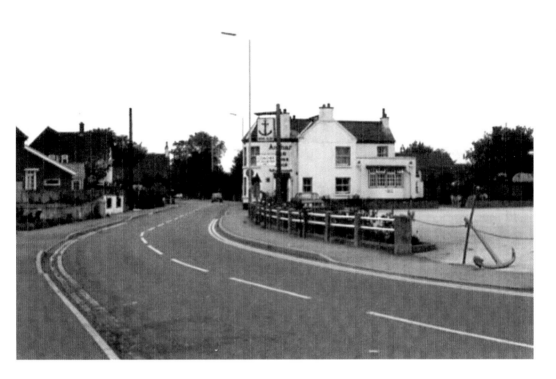

The Anchor Inn

The Anchor Inn was for many years the village pub, with a skittle alley in the buildings at the back, quite near to the River Trent. When trade was badly hit by the recession the pub closed, and was then refurbished and reopened as Portefino's restaurant.

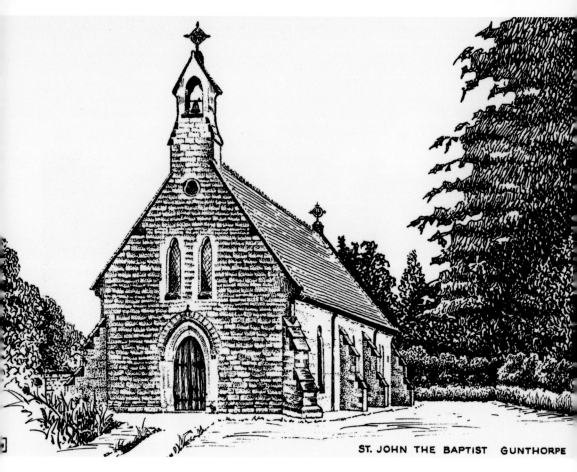

ST. JOHN THE BAPTIST GUNTHORPE

Gunthorpe Church

Originally part of the parish of Lowdham, in 1850 a chapel of ease was built in Gunthorpe, which eventually became a parish in its own right. The present church has been considerably extended, first in 1987, when the bishop visited Gunthorpe to dedicate the new building while it was in the process of erection, and then with the addition of a new church room in 2001.

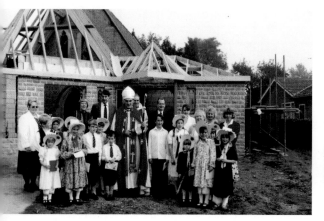

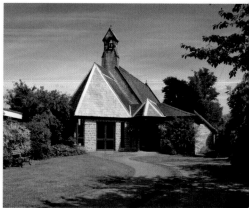

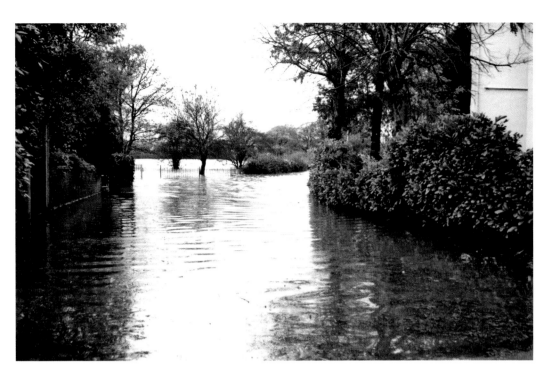

Vilage Floods

On various occasions, notably 1947, the two approach roads to the main village were flooded as the River Trent rose, and were impassable by foot or car. Despite this, the insides of very few houses in the village were actually flooded, having been built on slightly raised land.

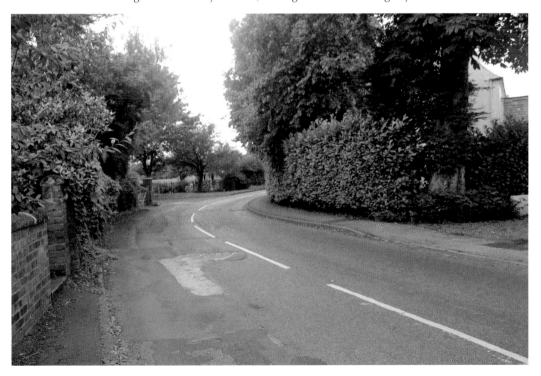

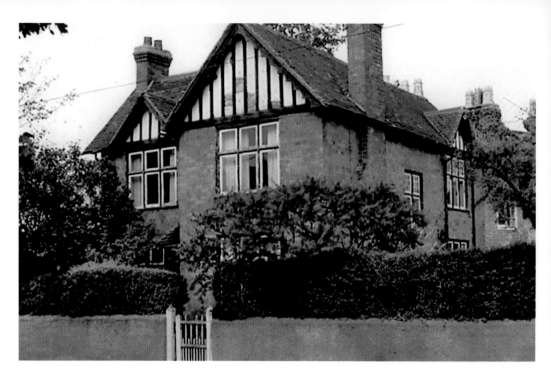

Granville House

Granville House was a large family house that, in its later years, was owned by the local shopkeeper. Eventually it was demolished, along with several cottages which lay behind it, and replaced with a road of new houses.

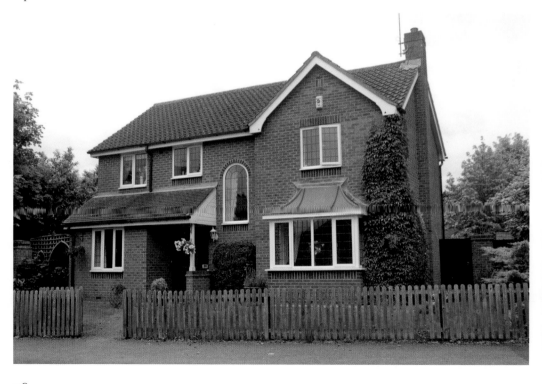

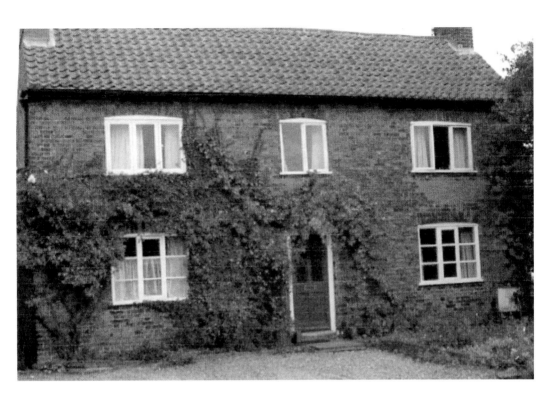

Holly Cottage

Holly Cottage, like so many in the village, was originally two cottages, which have been converted into one large house with an extension on the front.

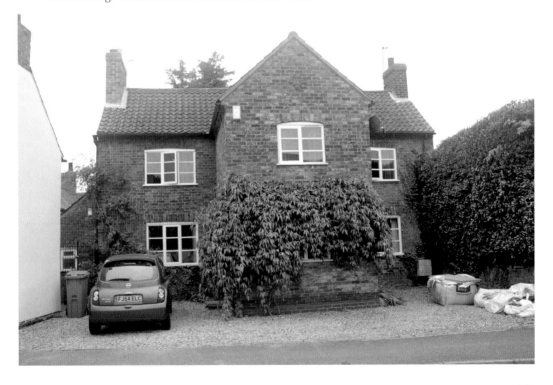

Home Cottage

A village mystery has never been solved regarding this cottage, which has always appeared lopsided from the front. The door has never been in a central position, with windows on the left-hand side apparently leading to a much larger room. Inside, steps led down into this left-hand room. At the back of the cottage, entered from the side, was the kitchen, which was also entered down some steps.

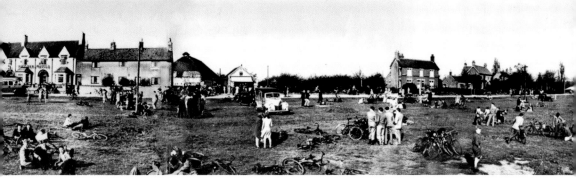

'Gunthorpe on Sea'

During the twenties and the immediate post-war years, Nottingham residents and those of other villages nearby visited Gunthorpe at the weekends for an afternoon out, particularly in the summer months, travelling by charabancs from Nottingham, on bicycles, or on the infrequent bus service. A walk to the lock was one of the highlights, for children especially, to watch the boats being ushered into the lock and either raised or lowered while travelling up- or downstream. This would usually be followed by a picnic on the wide Common in front of the Unicorn.

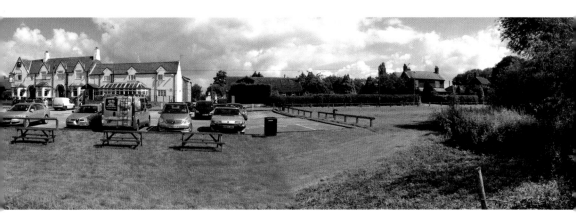

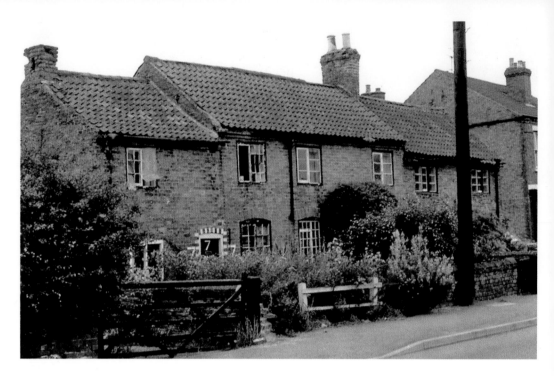

Main Street, Three Village Cottages
Another set of three village cottages, with Fern Cottage, the centre one, being slightly larger. In one of the end cottages, alongside a driveway to orchards, lived at one time the village carrier. Every Wednesday and Saturday he would drive his horse-drawn van into Lenton Street in Nottingham, where it would be parked for people to collect parcels. Others would bring parcels for the carrier to deliver on his homeward route at the end of the day. By the 1990s these cottages were demolished and two separate houses were built in their place.

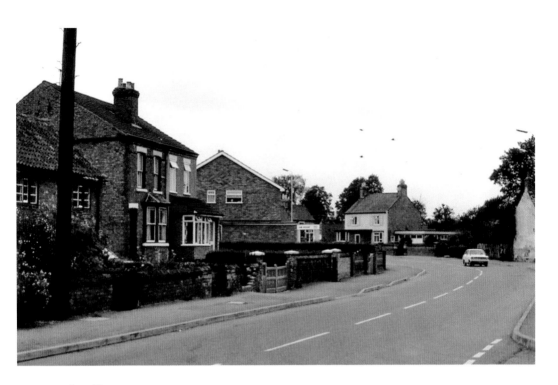

Acacia Villages

In this view of Gunthorpe's Main Street, two semi-detached villas, Acacia Villas, were occupied for many years by some of the oldest villagers. Eventually, the left-hand villa was left unoccupied and in some disrepair. It was then demolished and the right-hand house had a retaining wall built for safety. Later a detached house was built in the gap, which is shown in the present picture.

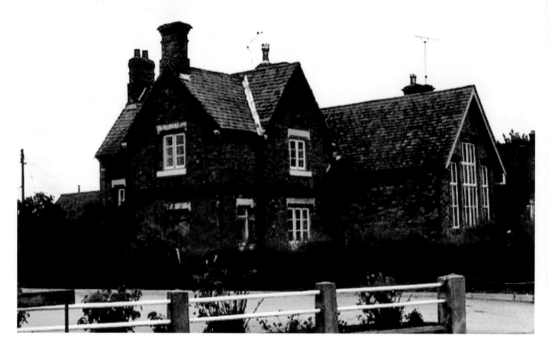

The Village School

The village school was a traditional school in the nineteenth century, with a house attached for the headmistress or headmaster on the left-hand side and the main building divided into two rooms, with a sliding door to separate two classes. In the twentieth century, the population of the village grew and another classroom was needed. A new school was built in David's Lane in the 1970s and all children transferred to it. The old school was converted into Tom Brown's, a restaurant that is still thriving today.

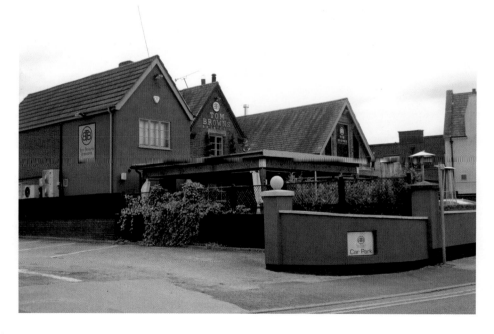

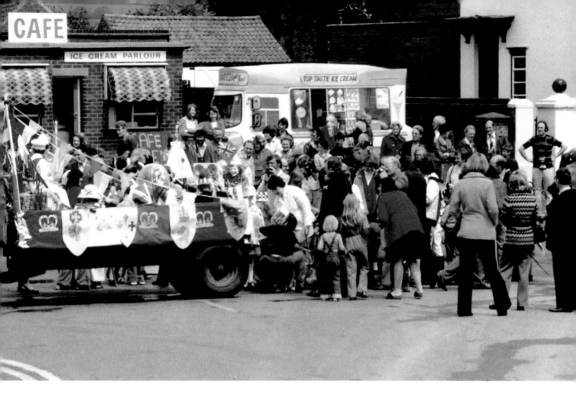

The Decorated School

The old school was decorated to celebrate the Queen's Silver Jubilee, with a decorated float and children dressed in period costume. The building became Tom Brown's restaurant when the school vacated this site and extensions were added.

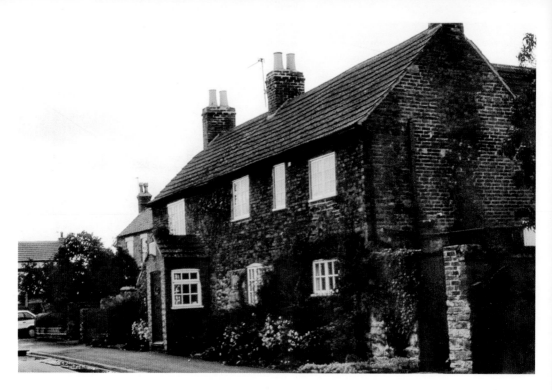

Pinfold House

At one time this house was the village post office, with land reaching back to the A6097 and a twitchel, or narrow lane, alongside it running from Main Street to the A6097. The house has been called Pinfold for many years, although the old village pinfold was between the manor house and workshops at the north end of the village.

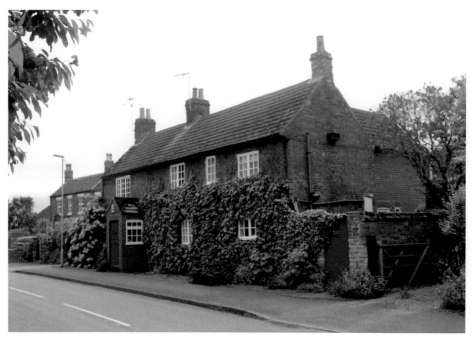

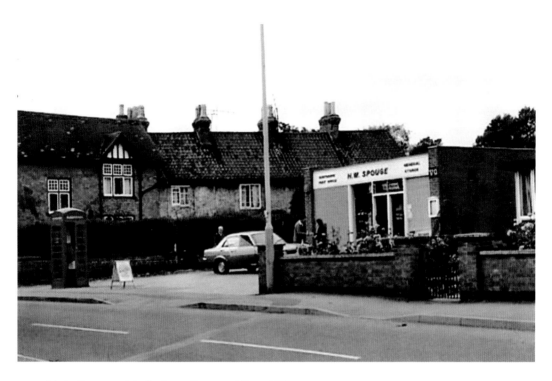

Main Street, with the Last Shop and Post Office

The last village shop and post office stood here, with a telephone box on the frontage. After considerable problems for the owner of the shop, the telephone box was moved to the river end of the village. By the time the shop was demolished, the box was not needed to the same extent, with the increase in the use of mobile phones. The post office was moved into a building at the Anchor Inn but finally closed towards the end of the twentieth century.

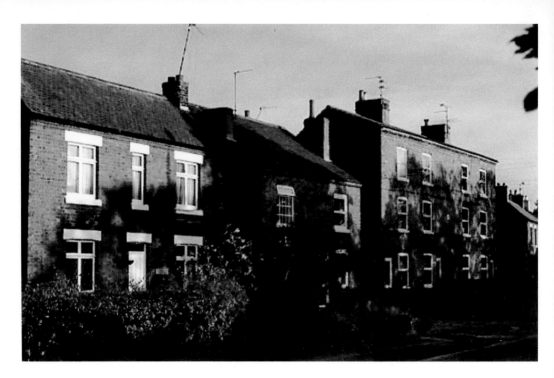

Station Terrace
In the nineteenth century when the railway station was built at Lowdham, these houses were built to cater for what was expected to be an influx of people. Whether anyone connected with the railway ever lived in these houses is unknown, but they were always called Station Terrace.

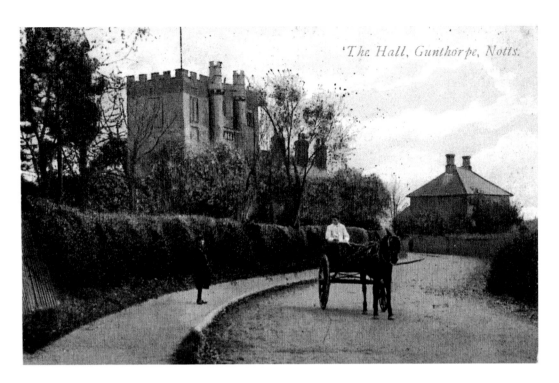

'The Hall, Gunthorpe, Notts.'

The Hall and Manor

Before the new bridge crossing over the River Trent was opened in 1927, the main road through the village curved closely between the Old Hall and the manor house, both of which are still occupied, although very hidden by trees and now further from the busy A9067, which was built to lead to the new bridge.

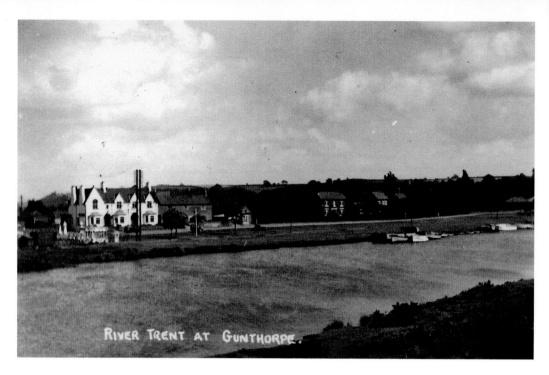

RIVER TRENT AT GUNTHORPE.

The Unicorn

The Unicorn, now a hotel, was another village pub, with cottages attached and further along the riverbank one of the framework knitters' houses, with their distinctive windows. The three cottages are now part of the Unicorn Hotel, with bedrooms commanding a view of the river.

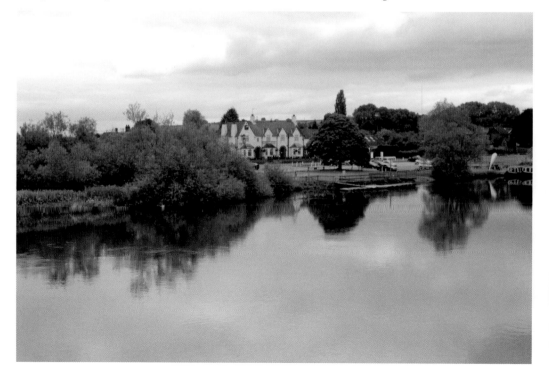

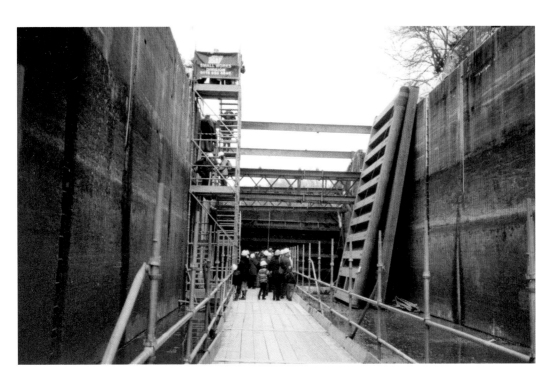

Gunthorpe Lock, Empty and Full

When it was decided to replace the gates to the lock at Gunthorpe in the 1990s, the contractors decided to open the drained lock over one weekend for people to walk along the bottom. Fully equipped with hard-hats, considerable numbers of people queued to go down the steps and walk past the new gates waiting to be installed – a rare chance to realise how tall the gates are and absorb the depth of the emptied lock.

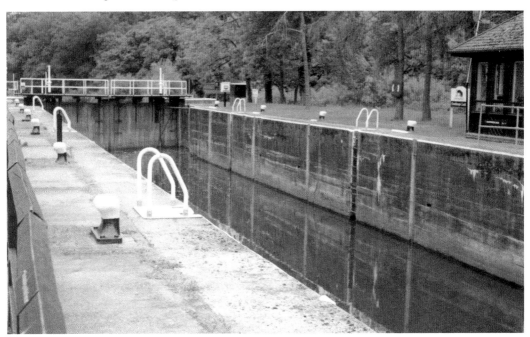

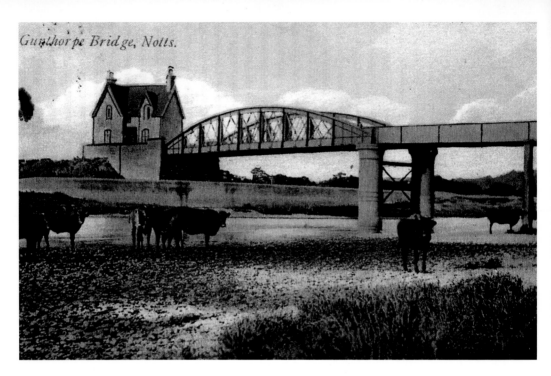

Gunthorpe Bridge, Notts.

Gunthorpe Toll-Bridge

The toll-bridge, built mostly of iron, was erected in 1873–75 by the Gunthorpe Bridge Co. In 1925 the tolls were horse-and-cart, 1*s*; horse alone, 3*d*; cars, 1*s*; lorries, 2*s* 6*d*; people and passengers, 1*d*. In 1925 the Council bought the owners out and demolished the toll-bridge, which was replaced by the present bridge, opened in 1927 by the Prince of Wales.

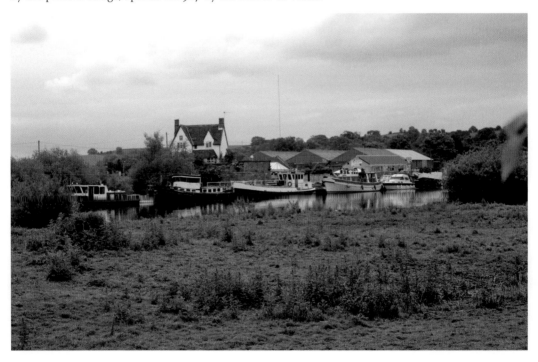

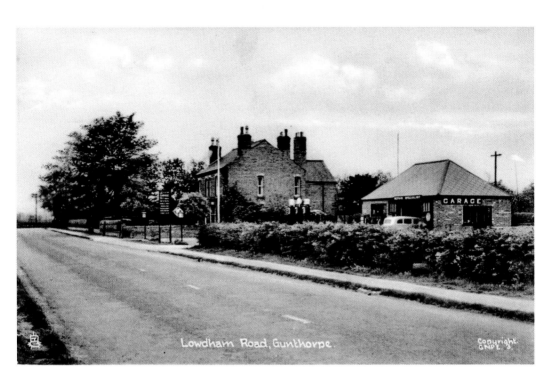

Lowdham Road, Gunthorpe.

The Village Garages
With the increase in road traffic, two garages were erected, one on either side of Lowdham Road at the approach to the village Main Street, one with pumps adjoining Prospect Villas, although these pumps were later moved nearer to the village and replaced by a workshop. Neither of these exist now, although some light industry is situated along the A6097.

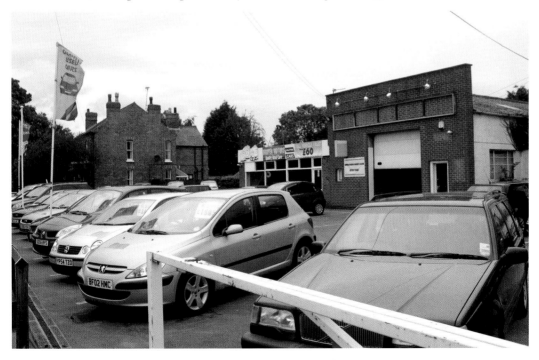

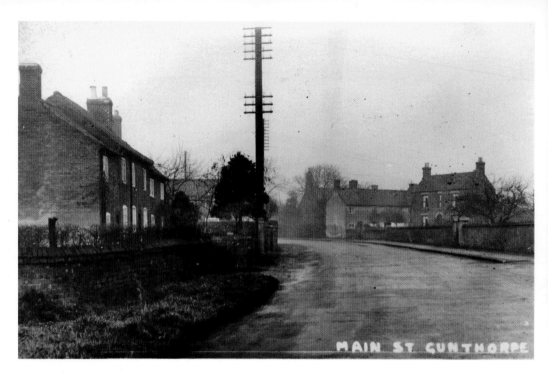

Gunthorpe Main Street

A time when the right-hand side of Main Street had a few large houses and the old cottages, still in use, were at right angles to Main Street, usually with an unsurfaced approach lane.

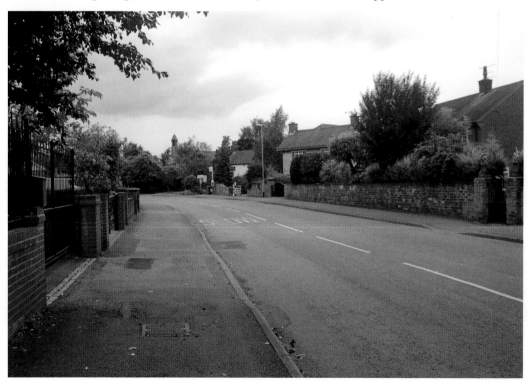

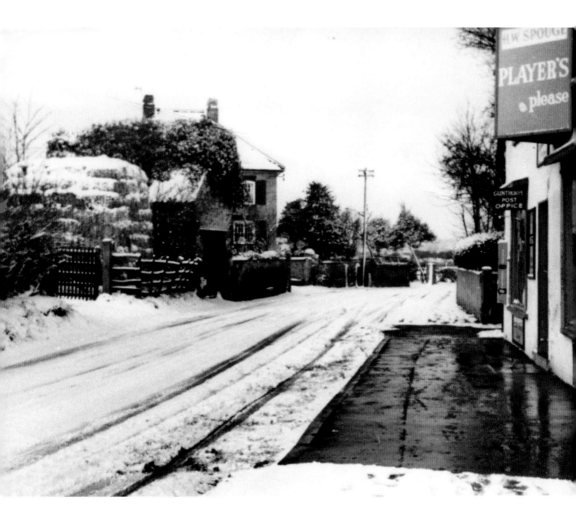

The Post Office Over Time
The post office changed its location several times over the years of its existence at this end of the village, away from the river. It started close along the edge of the village Main Street, with a large slab in the front that was regularly scrubbed and swept clean.

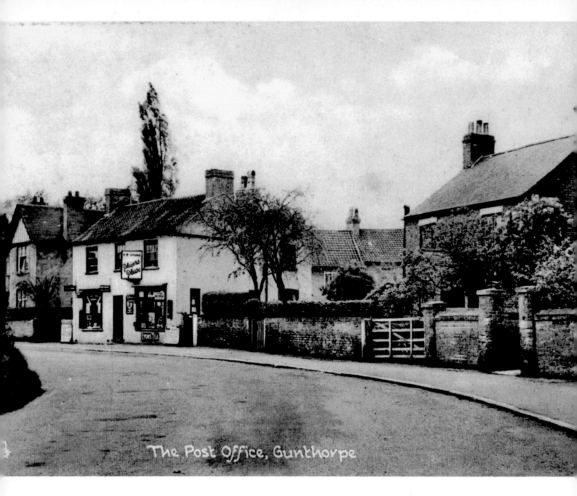

The Post Office, Gunthorpe

The Post Office and Cottages

Cottages surrounded the village shop-cum-post-office for some years, when the shop was a focal point for the village. The considerable increase in cars in the village limited the use of the local shop, as so many people started shopping more cheaply in large supermarkets or somewhere nearer to their workplaces, and eventually the shopkeeper retired and the area was resettled with new houses.